Better Homes and Gardens®

FLORAL NEEDLEPOINT

© Copyright 1990 by Meredith Corporation, Des Moines, Iowa.
All Rights Reserved. Printed in the United States of America.
First Edition. First Printing.
Library of Congress Catalog Card Number: 89-82442
ISBN: 00-696-01854-3 (hard cover)
ISBN: 0-696-01855-1 (trade paperback)

BETTER HOMES AND GARDENS® BOOKS

Editor: Gerald M. Knox
Art Director: Ernest Shelton
Managing Editor: David A. Kirchner
Project Editors: James D. Blume, Marsha Jahns,
Project Managers: Liz Anderson,
 Jennifer Speer Ramundt, Angela K. Renkoski

Crafts Editor: Sara Jane Treinen
Senior Crafts Editors: Beverly Rivers,
 Patricia Wilens
Associate Crafts Editor: Nancy Reames

Associate Art Directors: Neoma Thomas,
 Linda Ford Vermie, Randall Yontz
Assistant Art Directors: Lynda Haupert,
 Harijs Priekulis, Tom Wegner
Graphic Designers: Mary Schlueter Bendgen,
 Michael Burns, Brenda Drake Lesch, Mick Schnepf
Art Production: Director, John Berg;
 Associate, Joe Heuer;
 Office Manager, Michaela Lester

President, Book Group: Jeramy Lanigan
Vice President, Retail Marketing: Jamie L. Martin
Vice President, Administrative Services: Rick Rundall

BETTER HOMES AND GARDENS® MAGAZINE
President, Magazine Group: James A. Autry
Editorial Director: Doris Eby

MEREDITH CORPORATION OFFICERS
Chairman of the Executive Committee: E. T. Meredith III
Chairman of the Board: Robert A. Burnett
President: Jack D. Rehm

FLORAL NEEDLEPOINT
Editors: Nancy Reames and Beverly Rivers
Contributing Editor: Sharon L. Novotne O'Keefe
Project Manager: Jennifer Speer Ramundt
Graphic Designer: Brenda Drake Lesch
Contributing Graphic Designer: Patricia Konecny
Contributing Illustrator: Andy Haluska
Electronic Text Processor: Paula Forest

Cover projects: See pages 28 and 29.

CONTENTS

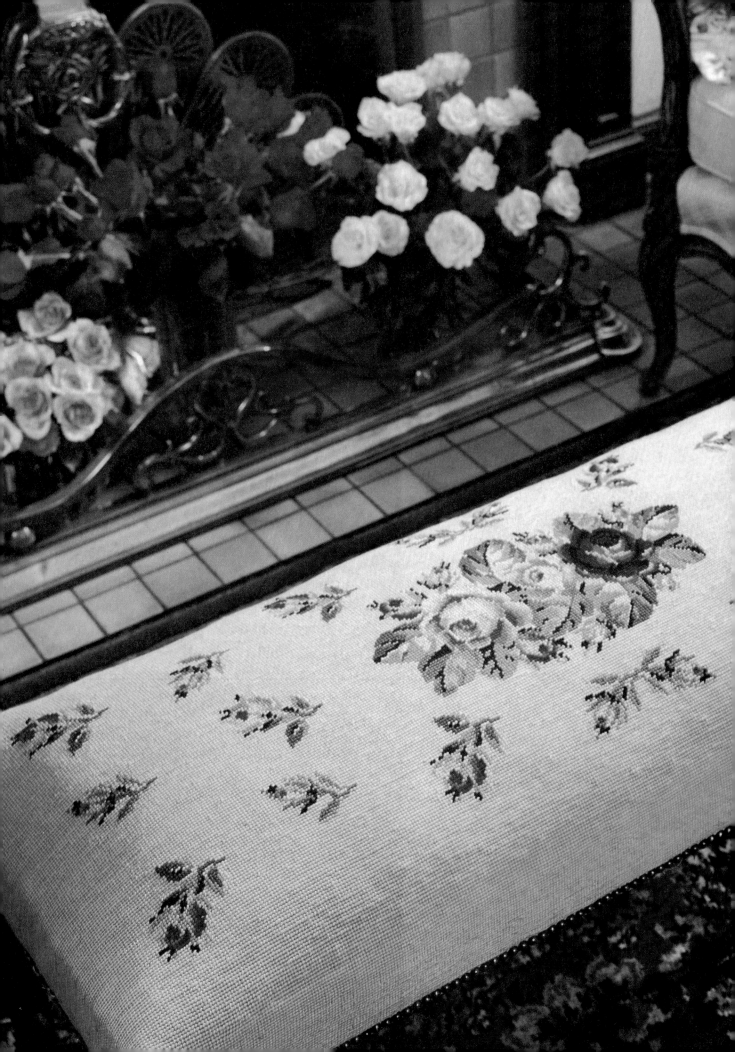

OLD-FASHIONED ROSES

IN ELEGANT BLOOM

As splendid rambling along a country roadside as it is in a manicured manor-house garden, the rose touches the poetry and romance of the soul. Over centuries, this regal bloom has inspired the works of needle artists, adorned the crests of kings, and buoyed the hearts of lovers. The rose-strewn needlepoint designs here and on the following pages add a nostalgic touch to the home.

Whether your collection of treasured old furniture is heirloom quality or dusty finds lovingly carted home from an antique shop, there's no better or more charming way to renew it than with fine stitchery.

For relaxing at a fireside or gathering with the family around the piano, this bench, *left*, is upholstered in a classic rose-motif needlepoint design that is easily adapted to seating pieces of various sizes. Worked in Persian wool on canvas, this design begins with a rose bouquet, measuring 6¾x12½ inches, at the center.

You can customize the size of the finished piece simply by repeating the rosebuds scattered over the canvas field.

Instructions for this project and tips for blocking needlepoint begin on page 11.

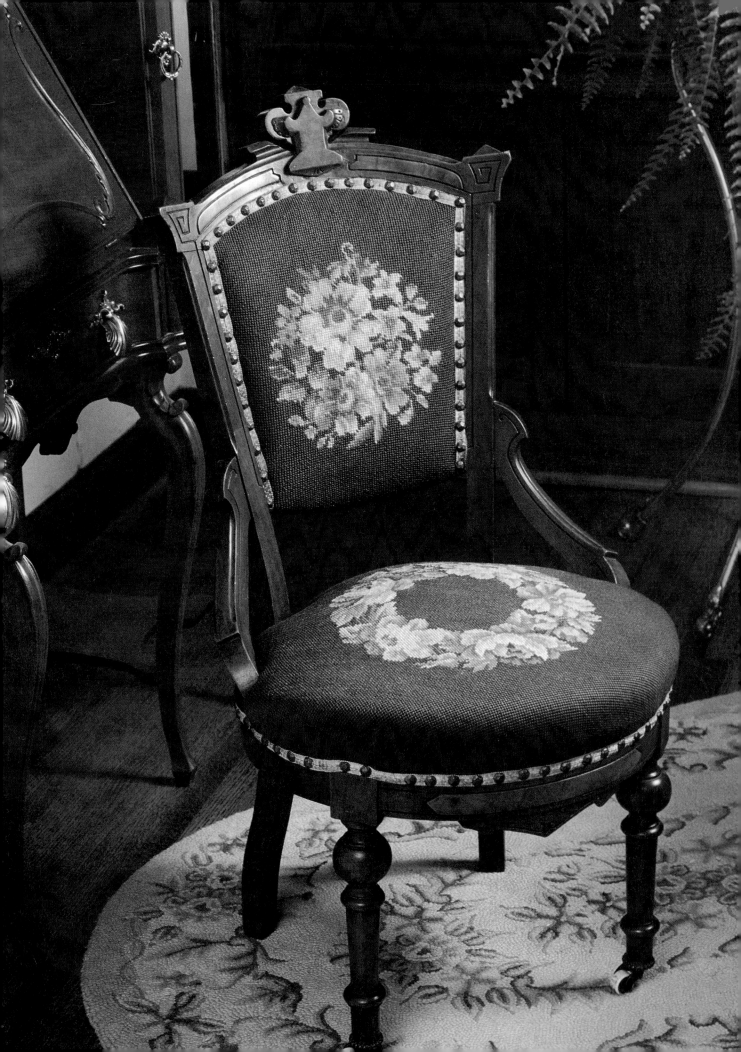

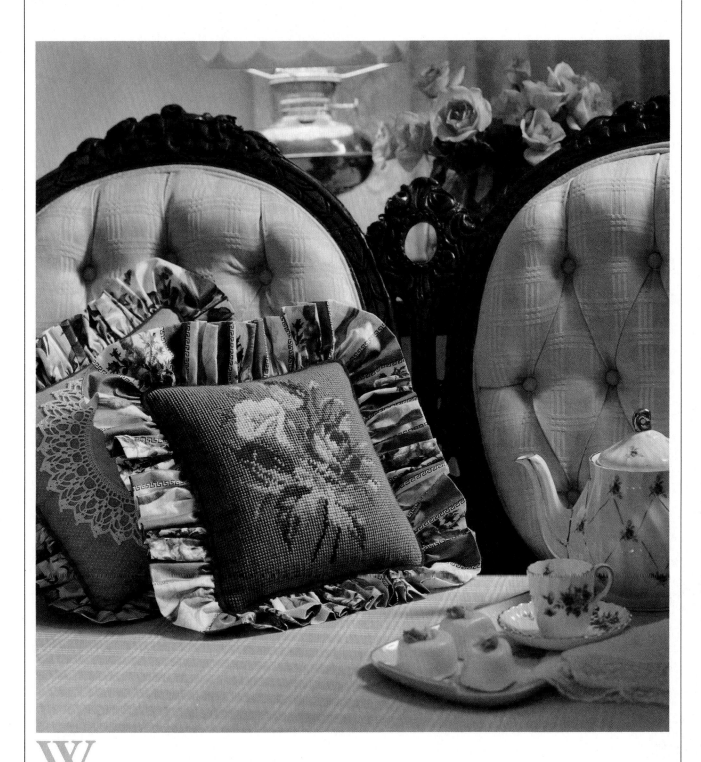

When the subject is roses, needlepoint accents can create a gardenlike ambience in almost any room.

The flower-and-leaf design on the upholstered Victorian chair, *opposite,* can be made to measure simply by adjusting the size of the background field.

Add the just-picked beauty of roses and daylilies anywhere with the needlepoint pillow, *above.* The finished pillow design measures 9x9 inches, excluding the ruffles. Instructions for these projects begin on page 14.

apturing the rich colors, the intricate forms, and the delicate, yet quite distinct, personalities of individual flowers has long challenged the artist, no matter the medium. Since the ancient Greeks, Chinese, and Egyptians first ascribed certain meanings to these natural wonders, floral lore, wrapped in mystery and sentiment, has evolved. The Victorians' special passion for flowers blossomed into a delightful array of home decorating accents, such as the botanical print, that we cherish today.

The pretty pair of framed rose-theme botanicals, *right,* is a lovely variation of these traditional prints. Measured from the inside edges of the mat, each botanical is 10½x13½ inches. Ecru perforated paper is used as the canvas, and each design is stitched with six strands of embroidery floss over one square of paper. Separating the strands before stitching lends a smoother look to the work. Show off your finished stitchery in elegant antique frames. Instructions for both botanicals begin on page 15.

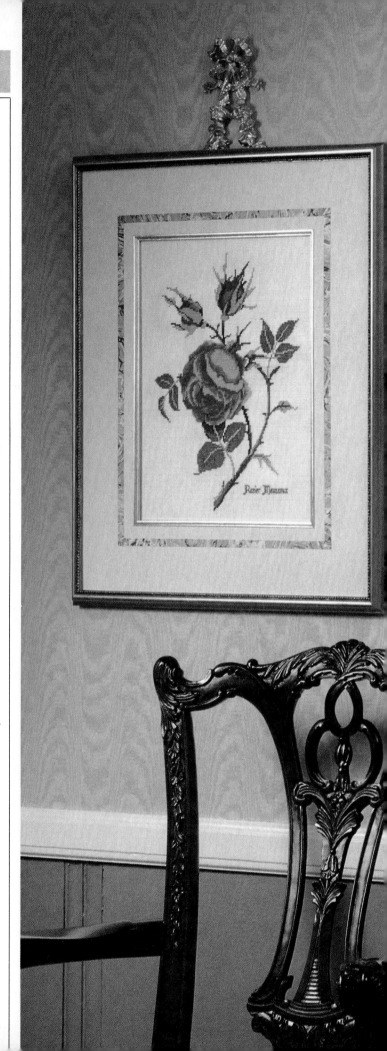

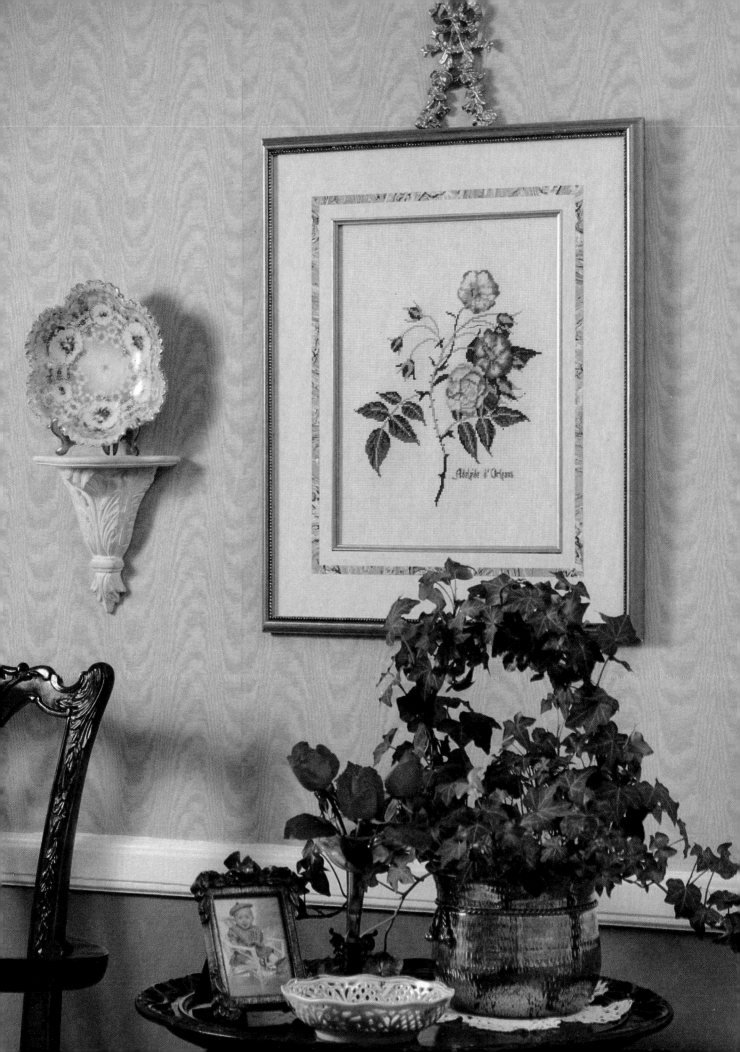

Adelaide d'Orleans

OLD-FASHIONED ROSES

1 Square = 1 Stitch

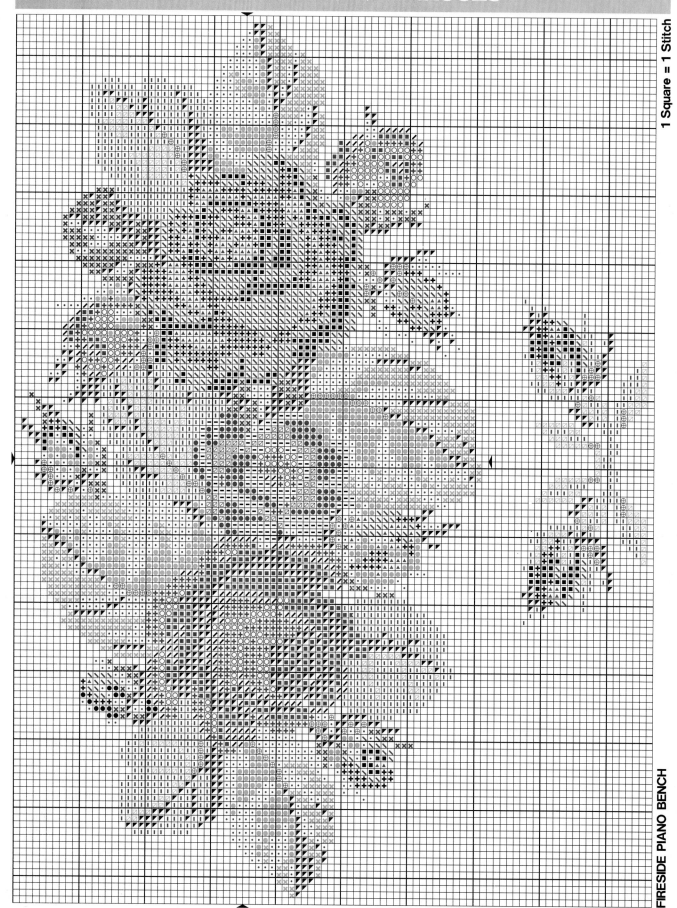

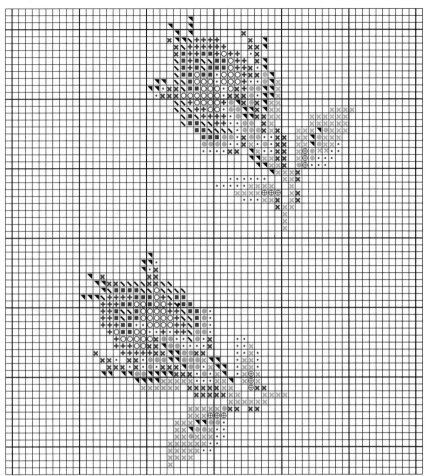

FIRESIDE PIANO BENCH

1 Square = 1 Stitch

COLOR KEY

⊠	Olive Green 691 (12)	⊡	Dark Tan 453 (2)	⊡	Light Olive 693 (14)	
▣	Celery Green 615 (11)	◉	Tan 454 (3)	⊠	Gold 742 (4)	
▪	Dark Rose 900 (5)	⊡	Light Tan 455 (3)	⊞	Rust 880 (3)	
◥	Rose 902 (3)	◩	Dark Peach 930 (4)	◥	Black 220 (12)	
⊕	Pink 904 (4)	⊞	Peach 932 (5)	⊟	Gray 532 (16)	
◎	Light Pink 915 (4)	☑	Light Peach 934 (7)	▢	Light Gray 534 (8)	
		▣	Pale Peach 948 (5)			

Fireside Piano Bench

Shown on pages 4 and 5.

Center motif measures 6¾x12½ inches. Adjust total size of desired piece by repeating the scattered rosebud field on each side of the center motif.

MATERIALS
10-count canvas that measures 5 inches wider on all sides than the bench top
Paternayan 3-strand yarn in the colors and number of yards listed in () on the color key
White paper tape
Tapestry needle
Bench

INSTRUCTIONS
The chart for the bench design appears *left* and *opposite*.

Note the location of the two buds at the bottom of the design, *opposite*. There are seven squares between the bud motif and the beginning of the larger rose medallion. To complete the pattern, flop the bud design and repeat it seven spaces above the top of the large medallion. (Refer to the photograph on pages 4 and 5 for guidance.)

Measure the top of the bench. Allow an additional 5 inches of unworked canvas on all four sides for mounting. Fold the canvas around the surface that will be covered to determine exactly how much background you will need to stitch. Include in your measurements the additional amount of background canvas that will require stitching if your bench will be padded. To figure the number of yards you will need to complete the background, estimate the square inches of background area to be covered and multiply the total square inches by 1.66 yards. The amount of yarn on the color key is for the center motif only.

Bind raw edges of canvas with tape to prevent raveling.

continued

Tips for Blocking Needlepoint

Blocking finished needlepoint restores the canvas's shape. Begin by cutting a blocking board from clean, ½-inch pine board. Make sure the board is at least 4 inches larger in both width and length than the needlepointed area and has straight edges. Cover the board with gingham fabric; use the checks to square the canvas.

Strengthen the canvas edges by sewing bias tape over them; sprinkle the needlepoint canvas with water until the yarn feels slightly damp on both sides. Center and tack needlepoint facedown to the blocking board. (Use rustproof tacks or pins.) Start tacking in the center of two opposite sides; work out to the corners on both sides, pulling as you go. Repeat for the last two sides. Make sure the edges align with the gingham checks.

Allow canvas to dry thoroughly; remove from board.

OLD-FASHIONED ROSES

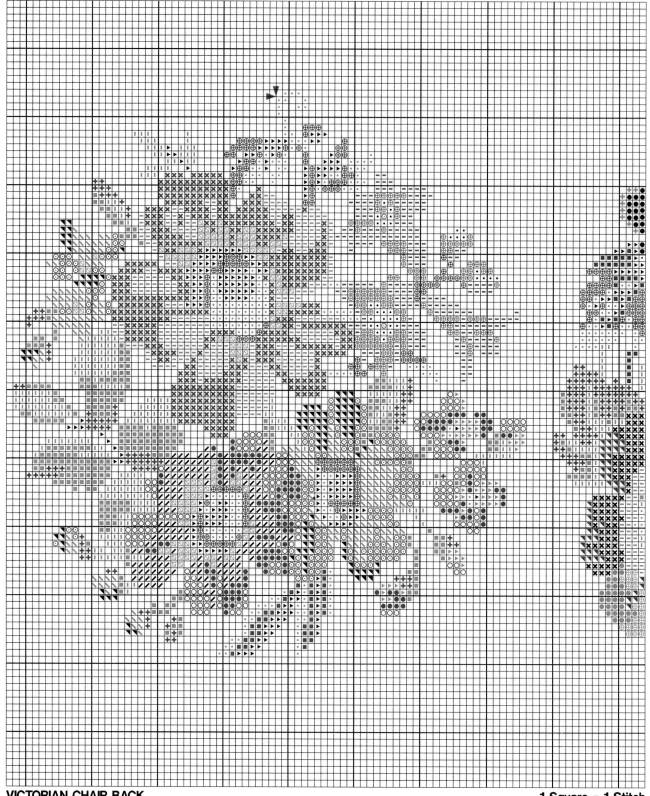

VICTORIAN CHAIR BACK

1 Square = 1 Stitch

COLOR KEY

▨ Dark Rust 871 (3)	◉ Coral 932 (10)	⊞ Light Dusty Pink 913 (5)
▷ Rust 872 (7)	⊞ Light Coral 933 (10)	◉ Pale Dusty Pink 915 (8)
◎ Pale Rust 875 (16)	⊡ Bright Red Pink 902 (3)	▨ Dark Wood Rose 921 (3)
◼ Light Rust 874 (6)	⊠ Dark Dusty Pink 911 (5)	◪ Wood Rose 923 (4)
	◣ Dusty Pink 912 (6)	⊠ Light Wood Rose 925 (9)

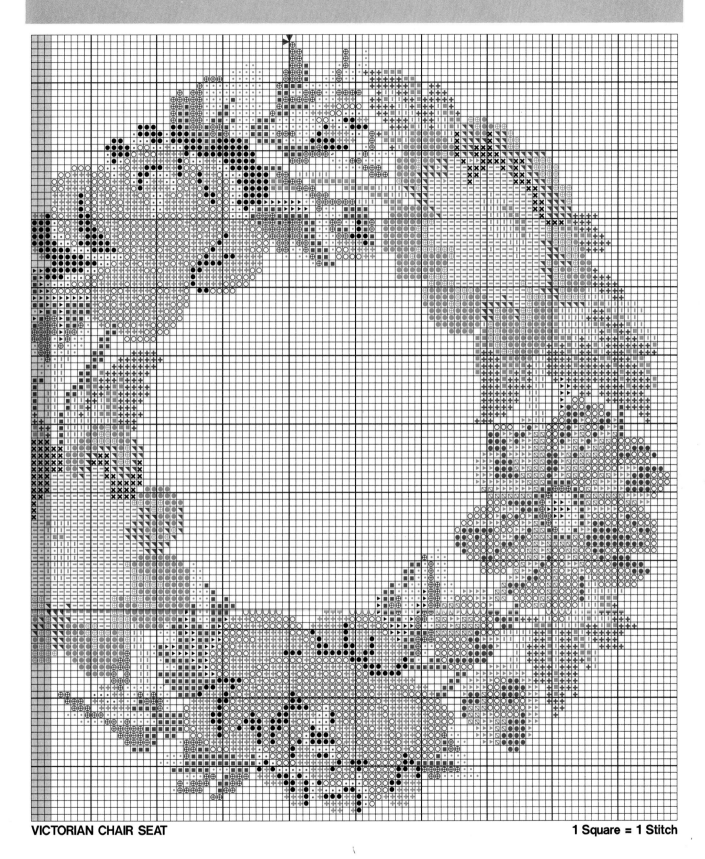

VICTORIAN CHAIR SEAT

1 Square = 1 Stitch

- ⊟ Pale Plum 327 (13)
- ⊡ Gray 200 (2)
- ⊞ Medium Gray 201 (3)
- ⊟ Light Gray 202 (3)
- ▶ Dark Khaki Green 640 (5)
- ▣ Olive Green 651 (7)
- ⊕ Light Olive Green 652 (8)
- ⊡ Light Khaki 644 (8)
- ⊡ Dark Forest Green 601 (9)
- ▦ Forest Green 603 (11)
- ⊞ Light Forest Green 605 (8)
- ◣ Dark Gold 731 (5)
- ◉ Gold 734 (5)
- ◥ Old Gold 753 (3)
- Federal Blue 501 (880)

Use three strands of yarn to work the design in continental or basket-weave stitch over one thread of canvas. Stitch diagrams appear on pages 24 and 25.

Find the center of the large rose medallion on page 10 and the center of the canvas. (The center of the medallion is indicated on the pattern by arrows.) Begin working the design here.

Work the flowers, leaves, and buds in continental stitch.

The pattern for the rosebuds scattered across the background is on page 11. To figure the number of yarn strands you need for each color, multiply the quantity given to the *right* of each color times the number of rose buds. Randomly place buds facing both directions across the canvas according to the space you need to fill. (Refer to the color photograph on pages 4 and 5 for guidance.)

Fill in the background area with light gold yarn in basket-weave stitch.

Follow blocking tips on page 11 to return the canvas to its original shape. Mount the needlepoint on the bench as desired.

Victorian Chair

Shown on page 6.

The chair back design measures 8x8½ inches and the seat design measures 10½x11½ inches.

MATERIALS
10-count needlepoint canvas
Paternayan 3-strand yarn in the
 colors and number of yards
 listed in () on the color key
Tapestry needle
White paper tape

INSTRUCTIONS
Charts for the chair back and seat motifs appear on pages 12 and 13. The shaded portion of the chair seat chart on page 13 is to be used only as a guide. The shaded stitches will help you move from the main part of the pattern on page 13 to the remainder of the pattern on page 12 without

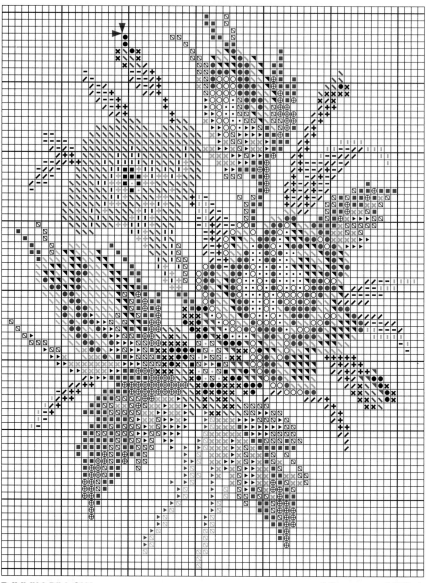

DAYLILY PILLOW **1 Square = 1 Stitch**

COLOR KEY

⊡ Dark Gray 201 (2)	⊠ Light Blue 515 (3)	◉ Medium Mauve 922 (7)
⊡ Light Gray 203 (2)	◖ Medium Blue 513 (3)	◳ Burgundy 901 (7)
⊠ Off White 260 (7)	◩ Dark Blue 511 (3)	◥ Dark Burgundy 920 (7)
⊞ Light Green 666 (8)	▷ Brown 472 (1)	⊡ Yellow Green 653 (3)
◙ Green 604 (9)	◧ Dark Brown 421 (1)	⊟ Medium Yellow Green 652 (6)
◪ Dark Green 650 (8)	☐ Light Gold 754 (1)	☑ Dark Yellow Green 650 (8)
▷ Gray Green 605 (8)	⊡ Dark Gold 732 (1)	⊕ Dark Forest Green 660 (7)
⊞ Dark Tan 642 (6)	⊡ Light Pink 947 (5)	Blue Gray 503 (110)
	◎ Mauve 924 (6)	

losing your place. Do not stitch shaded portions of these charts.

Measure chair back and seat areas you wish to cover before you begin. Add to these measurements an additional 2 inches of stitched canvas and an additional 2 inches of unstitched canvas on all sides for turning under during upholstering.

Chairs with removable seats are the easiest to cover. Chairs with seats that are not removable require the services of a professional upholsterer. Your upholsterer can help you determine the size and shape of the canvas if the chair or stool is unusual in design. Select an upholsterer who has experience with needlework coverings.

Bind raw edges of canvas with tape to prevent raveling.

After determining the size of the chair back and chair seat, locate the vertical and horizontal centers of the canvas pieces. On the chair seat canvas, measure up 6 inches from that center point to begin stitching the seat pattern.

On the chair back canvas, measure up 4 inches from the center point to begin stitching the back design. Use three strands of yarn to work the flower and leaf designs in continental stitch.

Use basket-weave stitch and blue (or color of your choice) to fill in the background according to the size previously determined. Refer to techniques for a bench on page 79 to figure the number of yards of yarn required for the background. Stitch diagrams appear on pages 24 and 25.

Block the stitchery, referring to blocking instructions on page 11.

Upholster the chair or stool as desired.

Roses and Daylily Pillow

Shown on page 7.

Finished pillow, excluding ruffle, is 9x9 inches.

MATERIALS
13-inch square of 10-count canvas
Paternayan 3-strand yarn in the colors and number of yards listed in () on the color key
1¼ yards of fabric for backing and ruffle, 40 inches of cording, and 40 inches of bias tape to cover cording, to make pillow as shown (optional)
Tapestry needle
White paper tape

INSTRUCTIONS
The chart for the pillow appears *opposite*.

Bind raw edges of canvas with tape to prevent raveling.

Use three strands of yarn on 10-count canvas.

Measure 3 inches down from the top and 5½ inches in from the left side of the canvas. Begin stitching at this point. (The starting position is indicated on the pattern by red arrows.)

Work the floral design in continental stitch. Fill in the background area with basket-weave stitches to complete a 9-inch square. Stitch diagrams are given on pages 24 and 25.

Block the finished needlepoint to restore the canvas to its original shape. See page 11 for blocking tips.

Assemble pillow as desired.

Rose Botanicals

Shown on pages 8 and 9.

Inside measurement of mats on botanicals is 10½x13½ inches.

MATERIALS
15x18-inch sheet of ecru perforated paper
DMC embroidery floss in the colors listed on the color key
White paper tape
Tapestry needle
Artist's stretcher strips to measure 15x18 inches assembled

INSTRUCTIONS
Botanical patterns appear on pages 16–19.

If more than one skein of any floss color is used, the amount needed is indicated in parentheses following the color number.

Assemble the stretcher strips and use this frame as you would use a needlepoint frame. Staple the edges of the paper to the top of the frame to hold the paper taut. Cover the raw edges of the paper with tape to prevent them from catching on threads and tearing.

Use six strands of floss over one square of the paper. Work in continental stitch. *Note:* Separating floss strands and putting them back together causes each stitch to lie more smoothly and makes the thread less likely to twist. This also loosens up the threads so they fill the area better.

Measure 3½ inches up from the bottom and 6½ inches in from the left side of each piece of paper. Begin working the bottoms of the stems here.

The shaded portions of the charts are for placement only. The shaded stitches will help you move, for example, from the portion of the pattern on page 16 to the remainder of the pattern on page 17 without losing your place. The second rose botanical pattern begins on page 18, with the top portion continuing on page 19.

Do not carry the floss from one area to another where it may show through to the front side of the finished needlework.

When stitching is complete, remove paper from the stretcher strips. Frame as desired.

OLD-FASHIONED ROSES

ROSE BOTANICALS

COLOR KEY

⊞ Light Pink 894	◉ Olive Green 732	■ Red 666	⊟ Soft Pink 818
⊡ Yellow 307	⊡ Avocado 469	◌ Medium Pink 893	⊕ Dark Pink 891
⊠ Deep Yellow 972	⊠ Dark Green 3345 (2)	⊠ Pink 776	◪ Rust 355
⊡ Light Avocado 471 (2)	◉ Light Green 368		

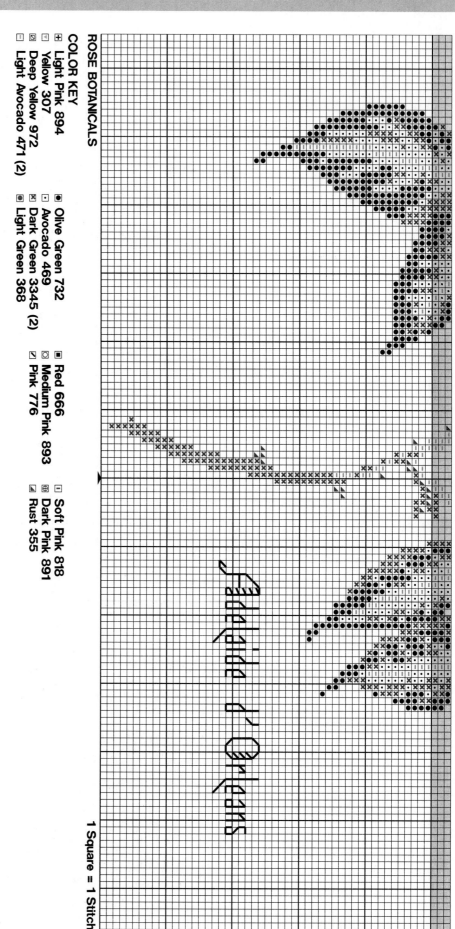

Adelaide d'Orleans

1 Square = 1 Stitch

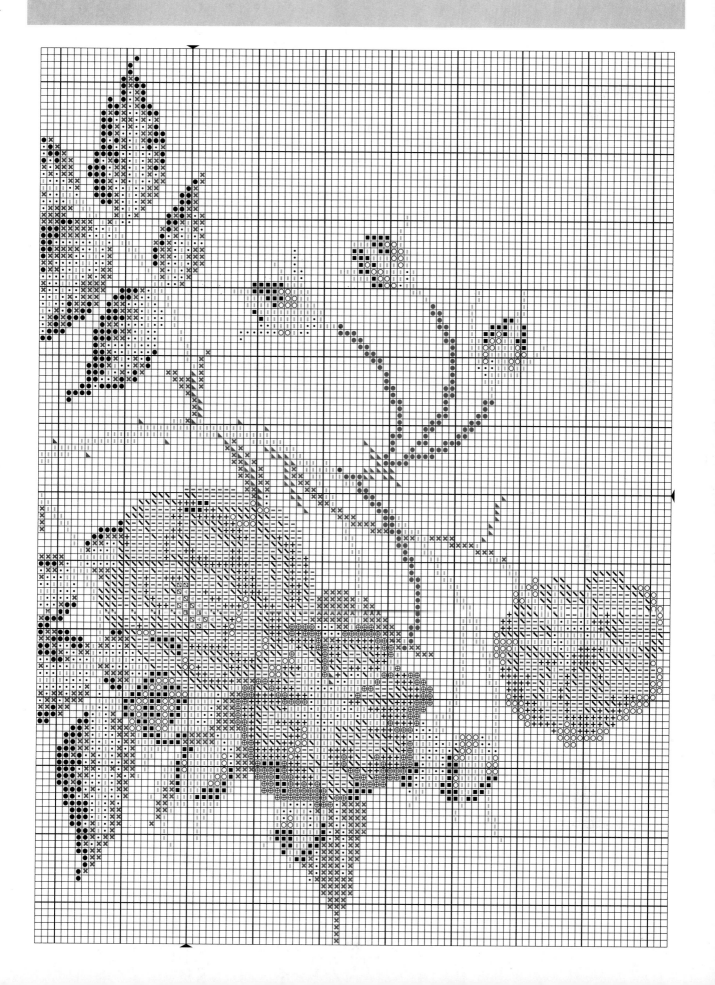

OLD-FASHIONED ROSES

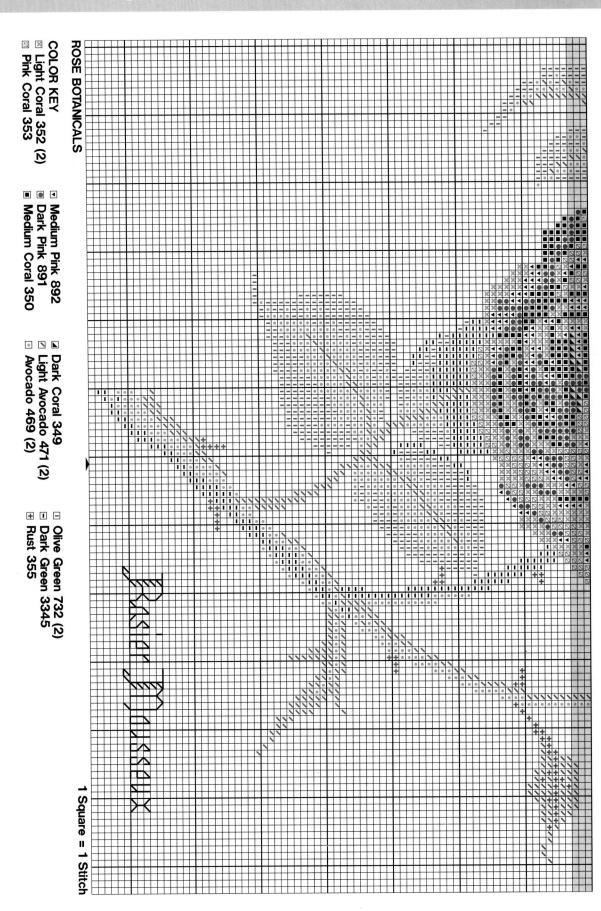

ROSE BOTANICALS

COLOR KEY

⊡	Light Coral 352 (2)	⊠	Dark Pink 891	
⊡	Pink Coral 353	⊡	Medium Coral 350	
		▶	Medium Pink 892	
		◉	Dark Coral 349	⊡ Olive Green 732 (2)
		▨	Light Avocado 471 (2)	⊡ Dark Green 3345
		⊡	Avocado 469 (2)	⊞ Rust 355

1 Square = 1 Stitch

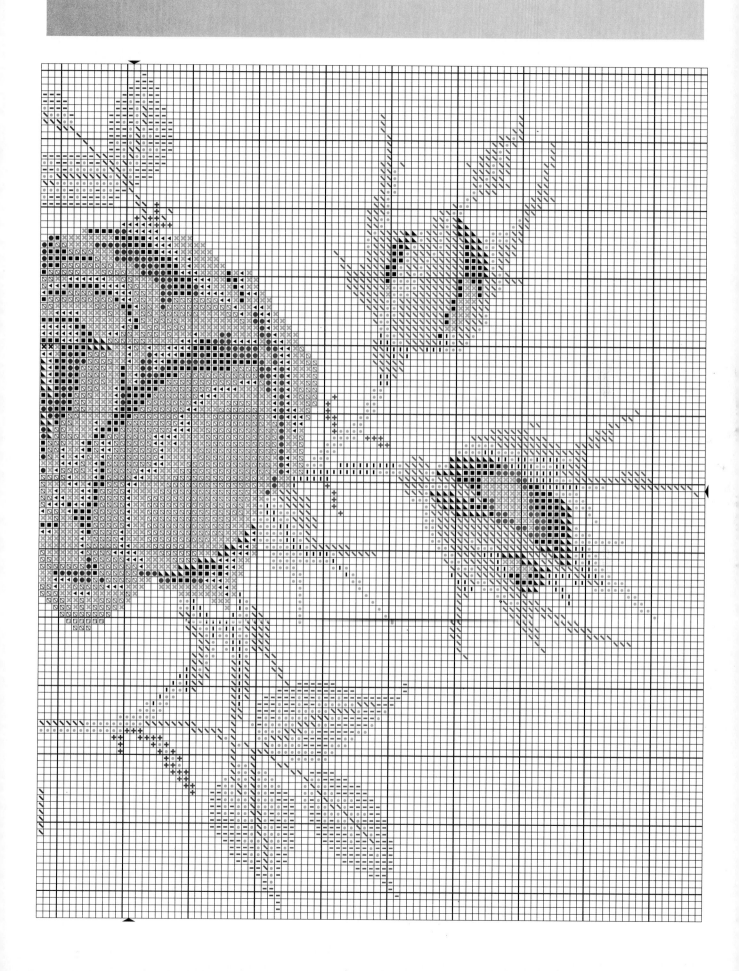

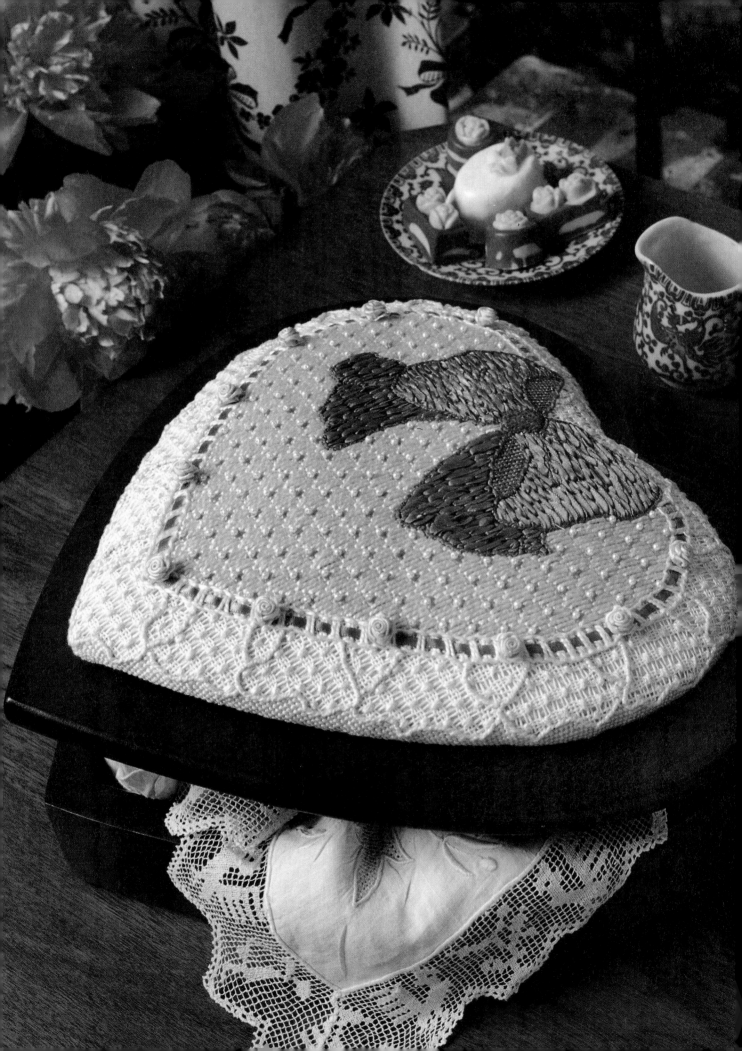

A KEEPSAKE HEART BOX

WITH A POTPOURRI OF STITCHES

Everyone has tucked-away treasures
that hold a very special place in
the heart. Perhaps it's Grandmother's
wispy lace-edged handkerchief still
scented with lavender, or
Grandfather's heavy gold watch that
he'd let you wind as you snuggled
on his lap. For these and other
mementos, this stitched-with-love box
makes an exquisitely fitting cache.
With an enduring motif and rich wood-
toned base, it's a pretty accent
destined to become an heirloom.

Our ancestors used all kinds of boxes—some plain, some fancy—for storing their cherishables. But this lacy beauty, *left,* isn't meant to be stored away.

Bedecked in yards of satiny ribbon and studded with pearls, the keepsake box adds an elegant touch of nostalgia clustered with charming collectibles atop a vintage table. Its fresh pastels make it the perfect bedroom accessory, and its utility even suits the dining room, where it might hold antique silver napkin rings. Start with a lidded wooden heart box with a muslin-covered insert. The needlepoint cover is 10¾x10½ inches finished. Worked on canvas in a medley of stitches, the topper is an intricate counterpoint of textures all tied up in a blue satin bow. Instructions begin on page 22.

Beaded Heart Box Cover

Shown on pages 20 and 21.

Finished size of the heart-shape cover is 10¾x10½ inches.

MATERIALS
18-inch square of 14-count canvas
2 pairs of 16-inch stretcher bars
DMC No. 3 perle cotton in the following amounts and colors: 3 skeins of cream (712), 2 skeins of light pink (118), and 1 skein *each* of blue (322) and medium pink (605)
5 skeins of DMC embroidery floss in light pink (818)
15 yards of ⅛-inch-wide blue satin ribbon
160 2½-mm white pearls; beading needle and thread
11 small light pink satin roses
Permanent ink pen
Tracing paper
Typist's white liquid correction fluid; cotton swabs
Heart box with 12x12 muslin-covered insert (available from Plain 'n Fancy Manufacturing Inc., Box 357, Mathews, VA 23109)

INSTRUCTIONS
Trace the full-size pattern, *right*, onto tracing paper. Place the tracing paper design on the canvas so the top edges of the heart rest on the same horizontal thread, and the dashed line of the center lies atop the same vertical thread of the canvas. Using the ink pen, transfer the design onto the canvas.

Mount the canvas onto the stretcher frames, stretching it as tight as possible. Leave the canvas on the frame until the ruffle and bow are worked. Then you may remove the canvas from the frame if you prefer working without a frame.

The heart pattern is coded with letters that indicate which stitch pattern is worked in that area. Refer to the lettered stitch diagrams on pages 24 and 25 as you follow the directions, *right*.

LACE RUFFLE: Using one strand of cream perle cotton and referring to Diagram A, backstitch the outlines of the ruffle and gathers over two meshes of the canvas, following the lines on the drawing. Referring to Diagram B, wrap the backstitches.

For the lacy interior of the ruffles, refer to Diagram I to work the coil filling stitch. Position the waste knot outside the heart design. For each coil stitch, wrap the thread over four canvas threads three times in a circular motion (front to back). In areas that are small and close to the outline stitches, wrap the coil stitches twice. To keep a circular motion to the ruffles as they swirl around the heart, work the coil stitches in the directions marked by arrows on the pattern.

BOW: Using one strand of blue perle cotton, outline the bow design in backstitch over two meshes, following the lines marked on the pattern. Then wrap each backstitch with the same ply and color of thread.

Cut ribbon into 1-yard lengths. Referring to Diagram C, fill the *bow loop areas* with horizontal brick stitches. Use small knots to start and stop these stitches.

Keep the ribbon untwisted and hold the needle perpendicular to the canvas as you make each stitch to avoid stitching into ribbon in previous row. *Note:* In counting out six meshes, if only one mesh is left at the end of a row, include that mesh in the last stitch.

Stitch the tail ends of the bow using brick stitches, except work them vertically on the canvas.

The knot in the center of the bow is worked in padded satin stitch using two strands of perle cotton. Referring to Diagram D, stitch the knot in horizontal satin stitch, then stitch vertical satin stitches atop the horizontal ones.

Referring to Diagrams E or F, fill the shaded portions of the bow areas with blue perle cotton working in continental or basket-weave stitch.

RIBBON CASING: To work the casing for threading the ribbon,

refer to Diagram H. Use one strand of cream perle cotton to work the double buttonhole stitches. First work one row of buttonhole stitches in every other mesh around the outside edge of the casing band. Then, work buttonhole stitches along the inside
continued

BEADED HEART BOX AND COVER
Full-Size Patterns

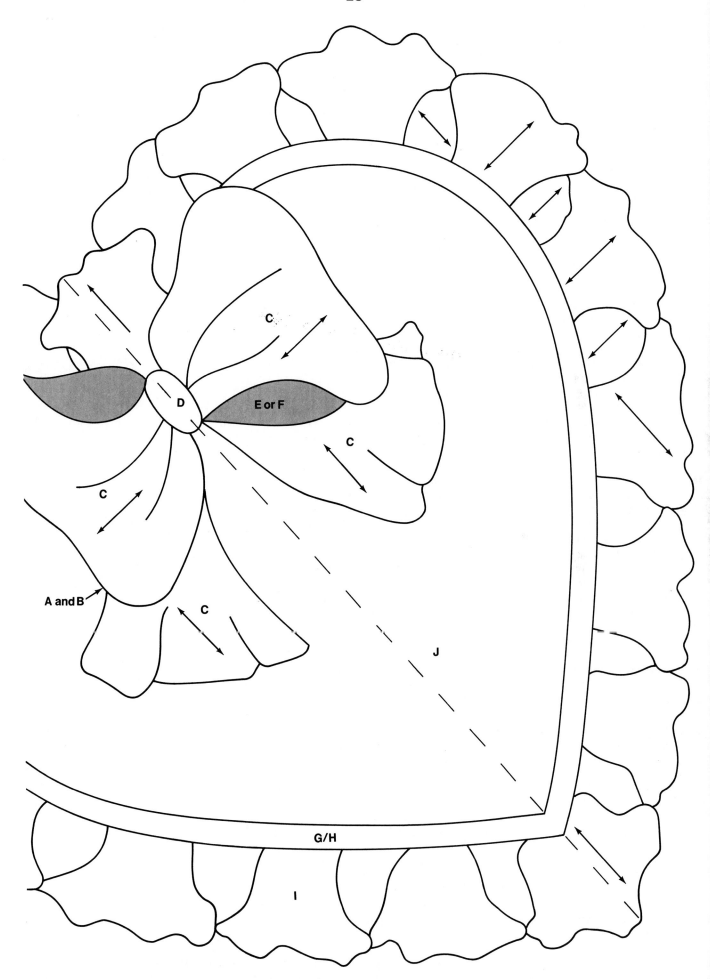

of the casing band, working the stitches in the empty holes. *Note:* Some stitch adjustments will be necessary when working around the curves. Sometimes you will need to fill a hole twice, or leave extra holes unstitched. These adjustments will not be noticed when the ribbon is in place.

When stitching is completed, use the white correction fluid to remove any pen marks that show.

BACKGROUND: Using one strand of light pink perle cotton, and referring to Diagram J, stitch the long-stitch heart pattern to fill the remaining unstitched areas of the heart. Adjust the long-stitch pattern to fill in the spaces along the bow and casing stitching. Use one strand of medium pink perle cotton to stitch the cross-stitches in the space between each heart.

To attach the pearls to the center of each cross-stitch, use the beading needle and two strands of beading thread. Come up from the back side of the canvas to the right side, go through the pearl and back down through the canvas. To lock the pearl in place, bring the needle back up through the canvas, separate the two strands, and, with one strand on each side of the pearl, poke the needle back down through the canvas; knot thread on the back.

OUTSIDE BORDER: To provide additional stitched area for mounting the heart onto the box lid, draw a line around the heart approximately 1 inch beyond the lace border. Fill in this area with basket-weave stitches using six strands of light pink embroidery floss.

FINISHING: Refer to page 11 to block needlework.

Weave the ribbon through the casing around the heart. Push the ends to the back side of the canvas and tack in place with thread.

Tack ribbon roses in place referring to the photograph on pages 20 and 21 for placement.

Mount following the manufacturer's directions.

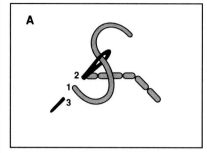

BACKSTITCH

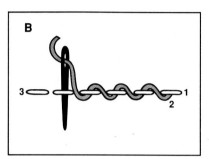

WRAPPING BACKSTITCH

GIANT BRICK STITCH

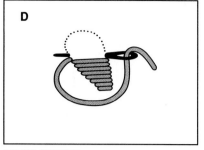

SATIN STITCH

CONTINENTAL STITCH

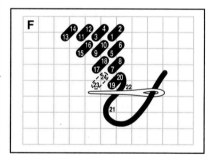

BASKET-WEAVE STITCH

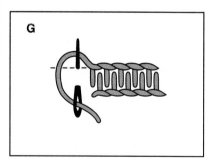

DOUBLE BUTTONHOLE STITCH

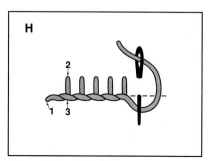

BUTTONHOLE STITCH

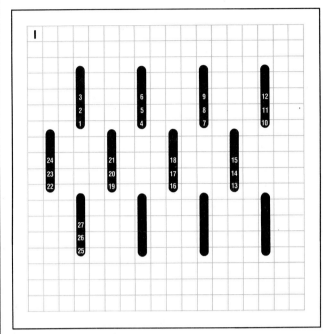

COIL FILLING STITCH

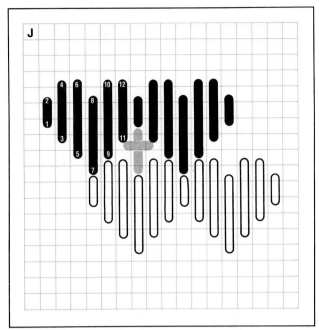

LONG-STITCH HEART PATTERN

Designing Your Own Needlepoint

Designing your own needlepoint project is fun, easy, and a great way to personalize your stitching. First, decide what you want to make—pillow, picture, or even a rug—then decide on the patterns you'd like to incorporate into your stitching. Design ideas are all around you—fabrics, wallpapers, photographs, your garden. Even a child's artwork can provide inspiration for your needlepoint project. For your first attempt, try something simple such as a basic geometric design. Draw your design to size on a piece of paper or directly onto the canvas. Allow an extra 2 inches of canvas on all sides for mounting.

As you become more skilled at designing, try to create designs with more shading and detail. When re-creating three-dimensional subjects such as your house, garden, or a person on canvas, take a photograph so the subject will be in the same two dimensions as it will on the canvas. Now you are ready to enlarge or reduce the design to fit your project.

ENLARGING AND REDUCING DESIGNS: The easiest way to enlarge or reduce a design is to have it photocopied on a machine that has such capabilities. Most quick printing companies can do this for a nominal fee.

To make a graph from the enlarged or reduced design, use a clear acetate sheet with a grid marked on it. These sheets are available at needlework stores and come in a variety of grid sizes to match the mesh you are working on.

Tape the acetate grid sheet over the design, or a portion of the design if it is larger than the acetate sheet, and transfer the design square by square onto graph paper that has the same grid size as your canvas mesh. Move the acetate grid sheet to another portion of the design if necessary, and repeat the transferring to graph paper. You may work from the completed graph or transfer the design to the canvas.

TRANSFERRING THE DESIGN TO THE CANVAS: First find the center of the canvas. Tape your design to a flat surface and place a sheet of acetate over it to keep it clean. Center your canvas atop the acetate, securing it with masking tape.

Transfer the entire design to your canvas by tracing over the pattern with a light-colored waterproof marker. (Avoid using a pencil because the yarn will pick up the graphite when you stitch and light-colored yarns may discolor.) This will give you the basic lines and shapes.

To add intricate shading detail, paint your canvas with acrylic paints. Acrylics work best because they dry quickly. Dab the paint colors on a paper plate; add a little water and mix. Paint a color key at the side of your canvas at the same time you are painting your design. Use a toothpick to remove paint from the canvas holes if necessary. Allow the paint to dry. After you pick yarn colors, cut and tie a snip of yarn to the side of the appropriate color in the color key.

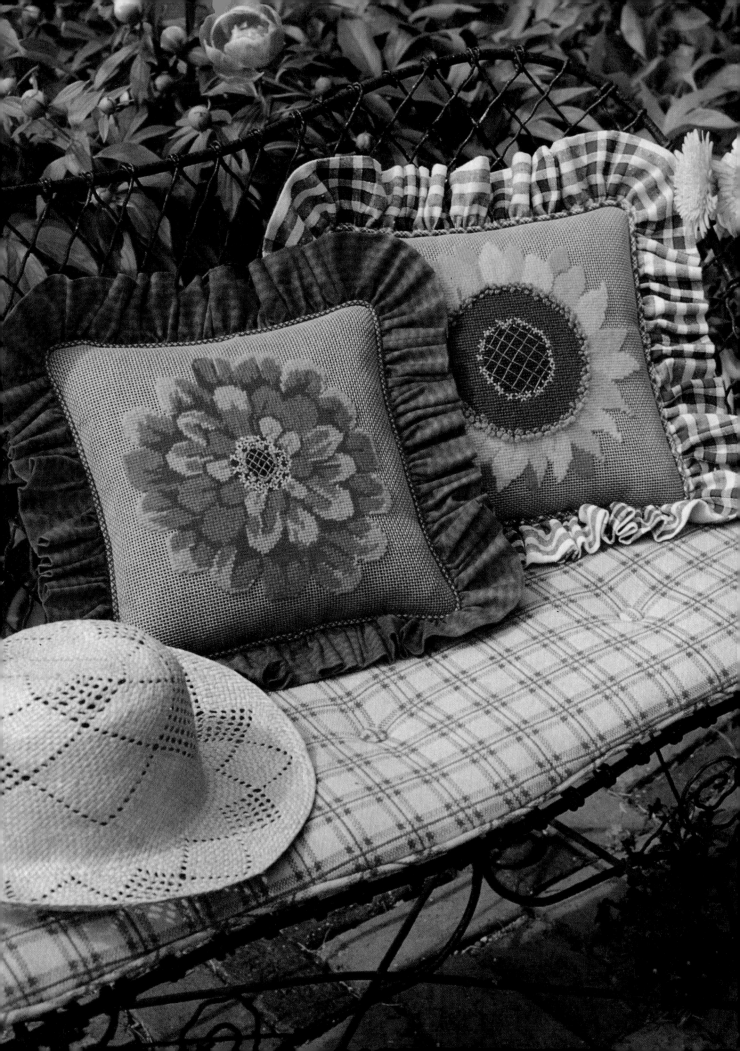

PERENNIAL ENJOYMENT

IN AN ENGLISH GARDEN

The brilliant bounty of the needle artist's garden is limited only by imagination and skill. The deep gold of sunflowers, vivid scarlet of zinnias and poppies, and soft purple of hydrangeas need not be a memory of summer past. With the projects here and on following pages, create an indoor garden that knows no season and gives new meaning to the word perennial.

It doesn't matter whether your warm-weather garden is measured by the country mile or by mere inches along a sunny windowsill, you can capture its drifts of color year-round on canvas—needlepoint canvas, that is. These easy projects coax any room into an English country mood simply by playing up favorites, those hardy perennials that provide a never-ending color show in real life and reward even the most forgetful gardener.

The appealing needlepoint pillows, *left,* star the sunflower and the zinnia worked in Persian wool and embroidery floss.

In these wonderfully realistic three-dimensional designs, only the blossoms are stitched, and the textured antique brown canvas background remains unstitched.

Tiny details, such as the flowers' seeded centers, are captured with finely embroidered cross-hatching and a bevy of French knots. Each pillow measures 11½ inches square, excluding the ruffle. Crisp country prints and ginghams are pretty fabric choices for the ruffling and backing. Instructions begin on page 34.

PERENNIAL ENJOYMENT

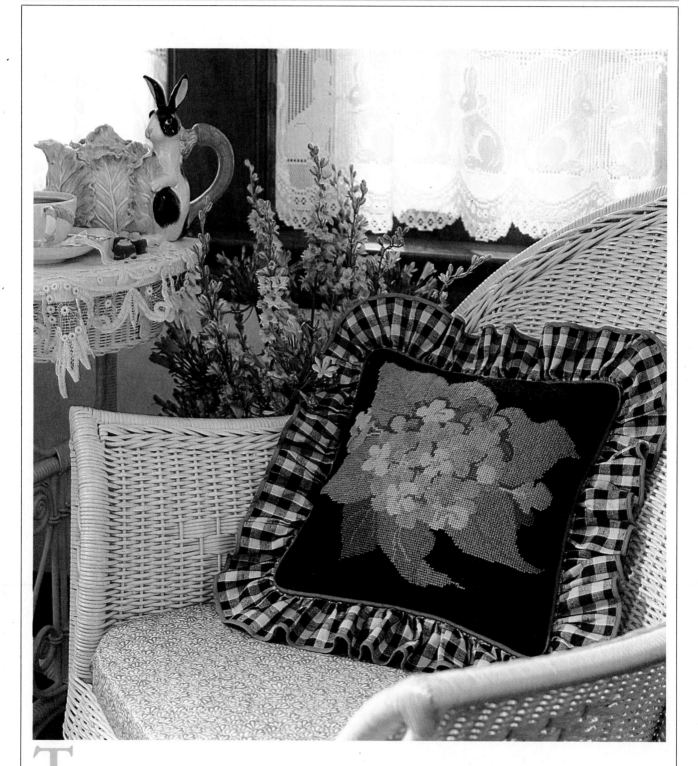

The lush blooms and regal purples of hydrangeas inspire the floral accents in this wicker-filled room. The needlepoint pillow and companion rug, *above* and *right,* are worked on 10-mesh canvas with Persian wool yarn. Since the area rug is based on a repeat pattern, you can customize the size. The finished rug measures 37x51 inches.

Instructions begin on page 43.

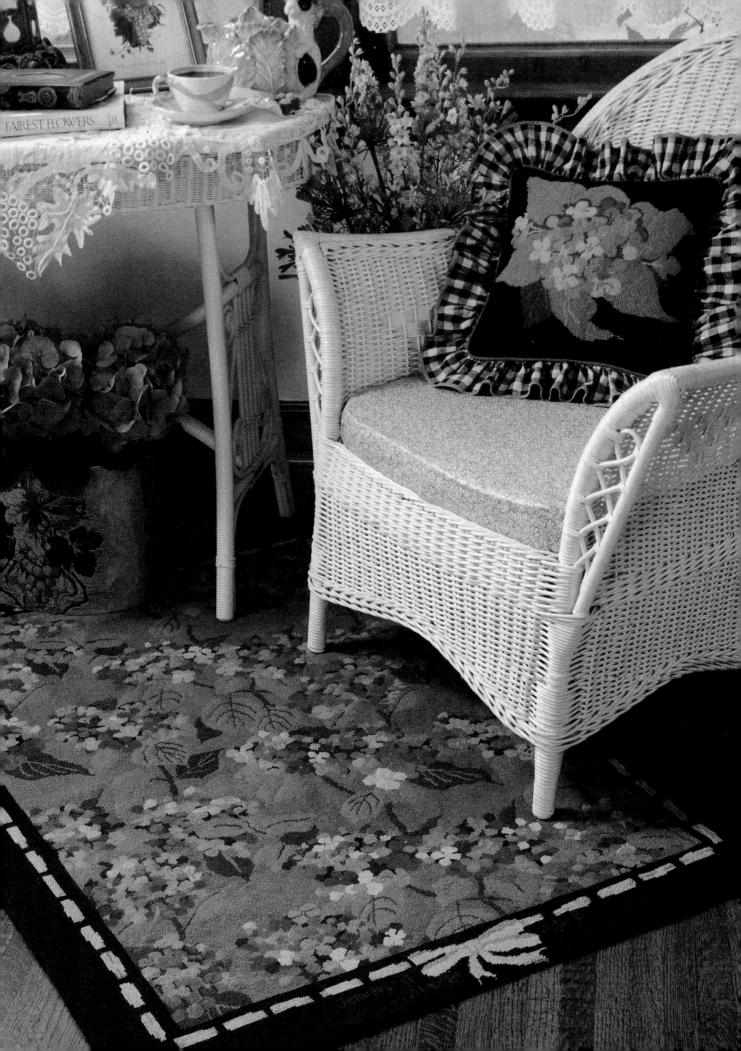

PERENNIAL ENJOYMENT

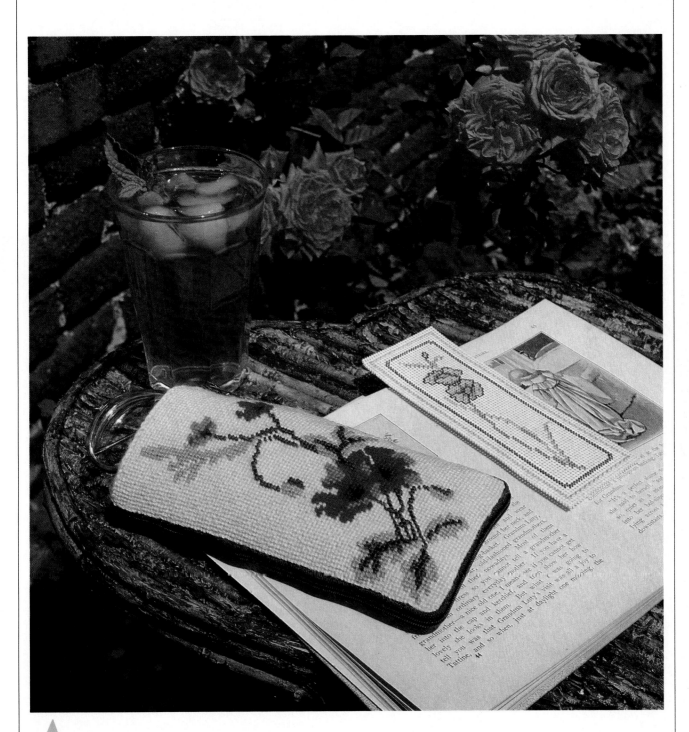

A gift of flowers is always filled with love. Whether you stitch these needlepoint accessories for yourself or for friends, they are decidedly pretty and practical.

The pattern for the poppy eyeglass case, *above,* includes how-to tips for making your own case and a source for finding a prefinished one.

The floral bookmark, *above,* is worked on one sheet of perforated paper and backed with another to hide the back of the stitching.

The 6x6-inch violet and rose sachets, *opposite,* are plumped with fragrant potpourri or fiberfill. Instructions for these accessories begin on page 44.

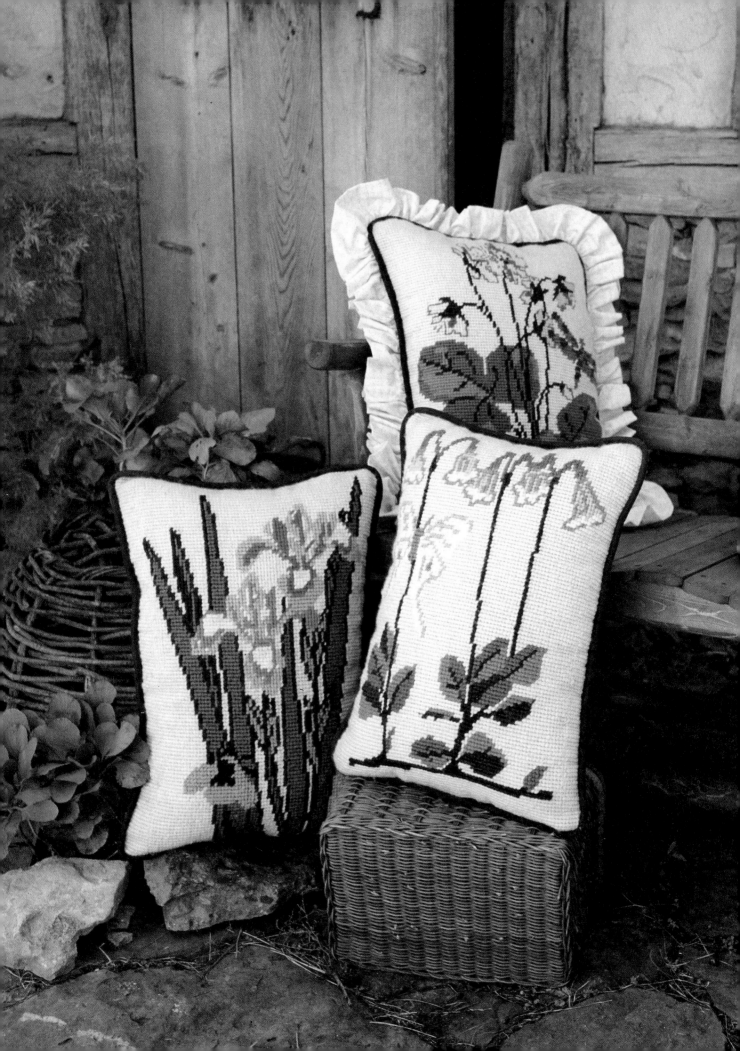

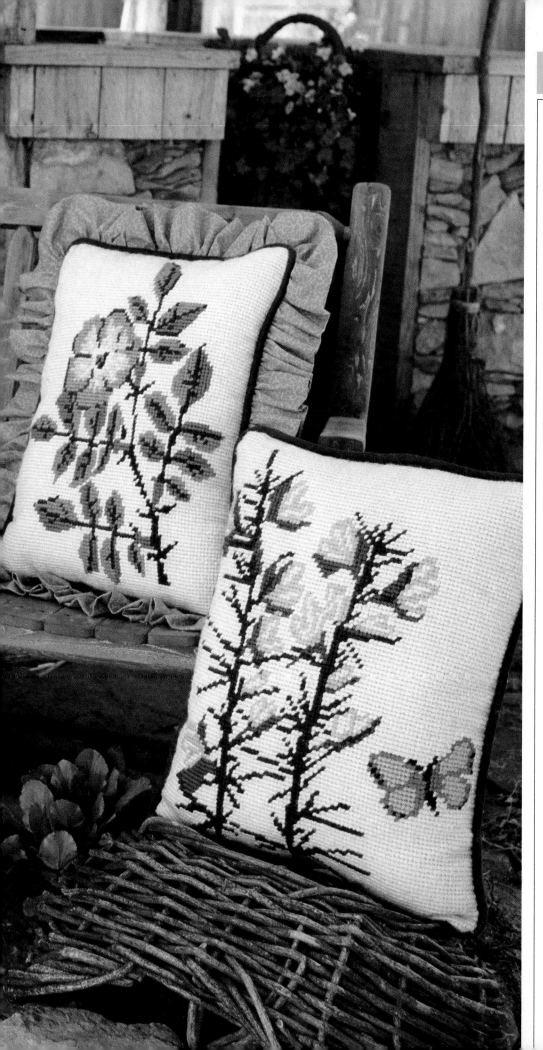

Y ou can almost smell the scent of springtime in this field of pillows, *left.* These bolster-size cushions will be a gentle reminder to you of that season's blossoms throughout the year.

The technique used to stitch these pillows is sometimes called "quick point" because of the large stitches used.

These 18x22-inch pillows, worked on 5-count rug canvas and stitched with six strands of Persian wool yarn, can be made in no time at all.

Instructions begin on page 46.

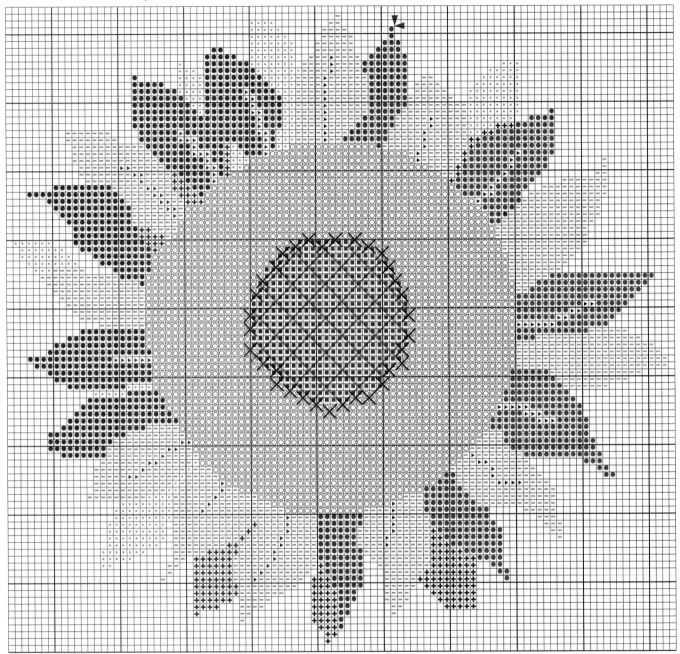

SUNFLOWER PILLOW

1 Square = 1 Stitch

COLOR KEY
- ⊡ Gold 733 (9)
- ⊞ Dark Gold 883 (6)
- ⊟ Yellow 713 (38)
- ◙ Dark Yellow 711 (33)
- ◪ Dark Brown 450 (10)
- ⊙ Khaki Green 641 (29)
- ▷ Green Gold 751 (4)
- Olive Green 652 (12)

DMC Floss
- Gold 742
- Tan 371

Sunflower and Zinnia Pillows

Shown on pages 26 and 27.

Pillows measure 11½ inches square excluding ruffle.

MATERIALS
For each pillow
15½-inch square of 10-count antique brown canvas

Paternayan 3-strand yarn in colors and number of yards listed in () on color key; 1 skein DMC embroidery floss in colors listed on color key
1 yard of fabric for backing and ruffle, 15½-inch square of dark-colored fabric to back canvas, 48 inches of narrow cotton cording, and 48 inches of bias binding for pillow as shown (optional)
White paper tape
Tapestry needle

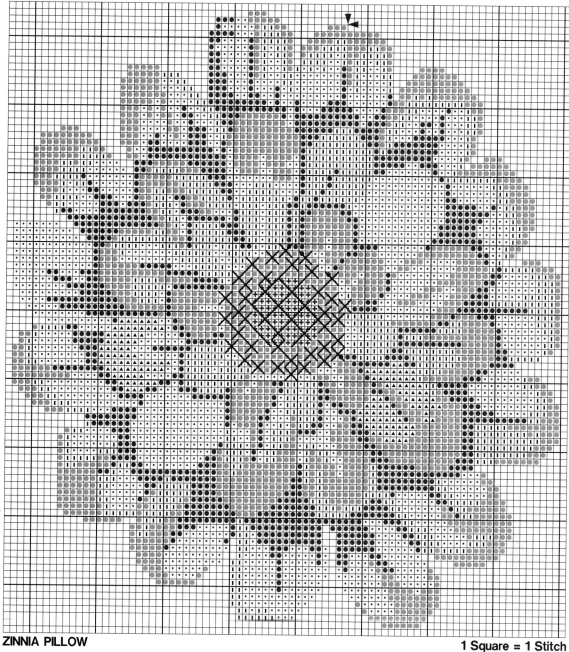

ZINNIA PILLOW

1 Square = 1 Stitch

COLOR KEY
⊞ Brown 920 (2)
⬓ Red 940 (4)
▲ Peach 954 (4)
◉ Dark Pink 943 (40)
⊡ Pink 944 (31)
⊞ Rose 905 (26)
▣ Light Pink 914 (35)
DMC Embroidery Floss
 Gold 742
 Tan 371

INSTRUCTIONS

Bind raw edges of canvas with tape to prevent raveling.

Using three strands of yarn, work the designs in continental stitch. Refer to pages 24 and 25 for stitch diagrams. Begin stitching the sunflower chart, *left,* at the red arrows 3½ inches from the top and 7 inches from the right-hand edge of canvas. Begin the zinnia chart, *above,* at the red arrows 3½ inches from the top and 6½ inches from the right-hand edge of the canvas.

FLOWER CENTERS: Use three strands of tan floss to work long-stitches atop both flower centers where the cross-hatch markings are located.

Use four strands of gold floss to make cross-stitches over two continental stitches at the X marks.

Referring to the photograph on page 26, stitch French knots around the center of the sunflower using three strands of olive green yarn; stitch French knots on the zinnia just inside the cross-stitches using three strands of tan embroidery floss.

BACKGROUND: The background is unstitched. Baste the dark-colored 15½-inch square of fabric to the back side of the canvas. Assemble pillows as desired.

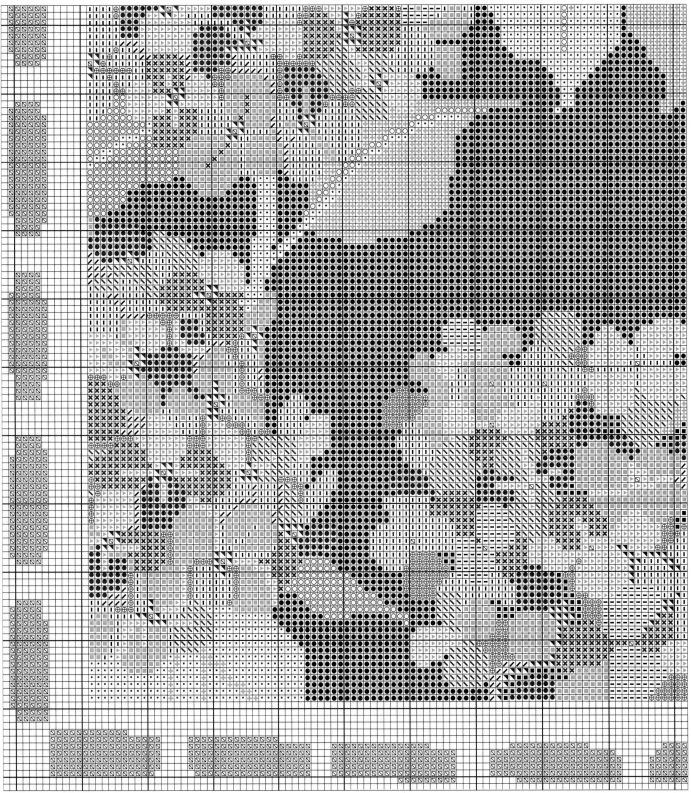

HYDRANGEA RUG (Chart A) 1 Square = 1 Stitch

COLOR KEY

◪ Light Purple (92)	⊡ Light Olive 652 (173)	⊡ Brown 641 (138)	◉ Lavendar 333 (103)
◙ Gray 562 (461)	⊠ Light Gray Blue 514 (86)	⊡ Tan 643 (125)	◥ Steel Blue 511 (31)
⊡ Light Grape 313 (135)	◩ Light Blue 504 (54)	⊠ Mint 614 (141)	⊟ Light Plum 325 (107)
⊕ Purple 330 (94)	⊡ Light Periwinkle 342 (127)	◿ Dark Gray 200 (40)	⊡ Gray Green 604 (11)
	⊡ Periwinkle 341 (136)	■ Navy Blue 510 (958)	⊙ Light Green 605 (8)

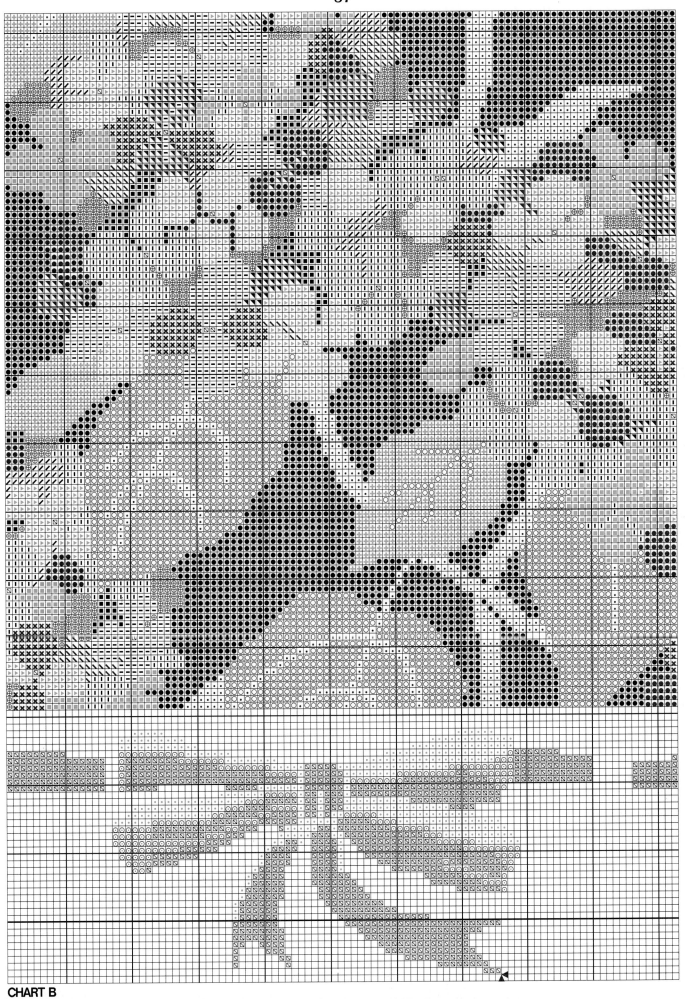

CHART B

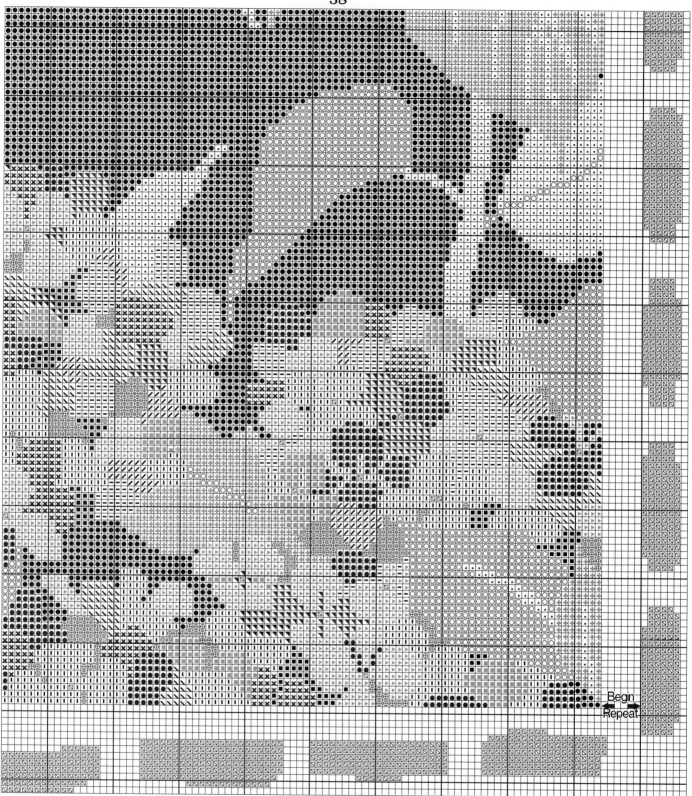

Begin
Repeat

CHART C

1 Square = 1 Stitch

COLOR KEY

◨ Light Purple (92)
▣ Gray 562 (461)
▷ Light Grape 313 (135)
⊞ Purple 330 (94)

◫ Light Olive 652 (173)
☒ Light Gray Blue 514 (86)
◩ Light Blue 504 (54)
▣ Light Periwinkle 342 (127)
▯ Periwinkle 341 (136)

◻ Brown 641 (138)
⊡ Tan 643 (125)
◩ Mint 614 (141)
◿ Dark Gray 200 (40)
◼ Navy Blue 510 (958)

◨ Lavendar 333 (103)
◥ Steel Blue 511 (31)
⊟ Light Plum 325 (107)
◻ Gray Green 604 (11)
◌ Light Green 605 (8)

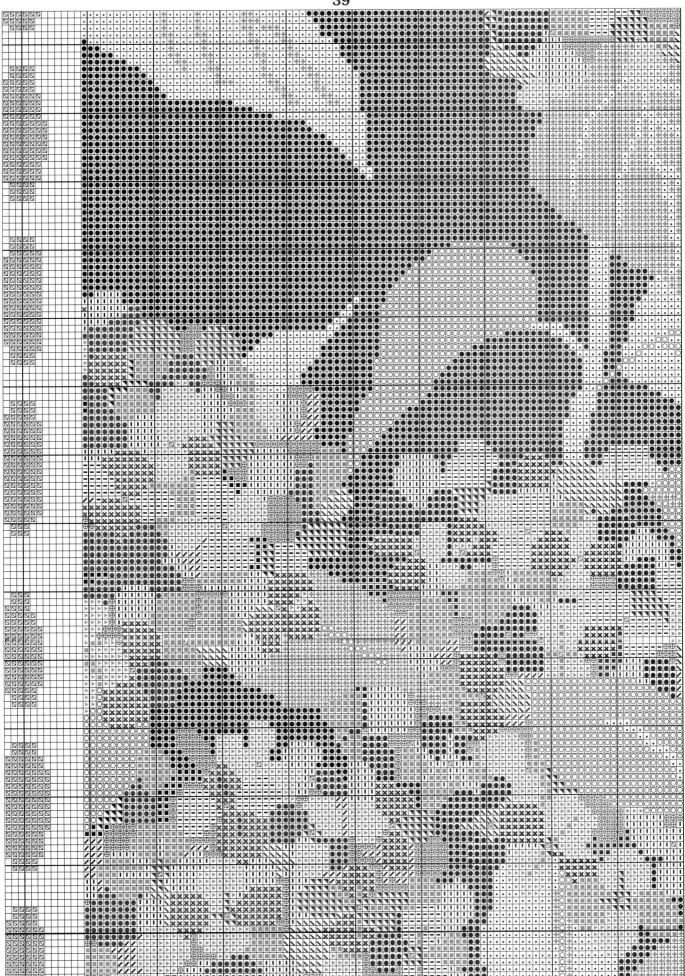

CHART D

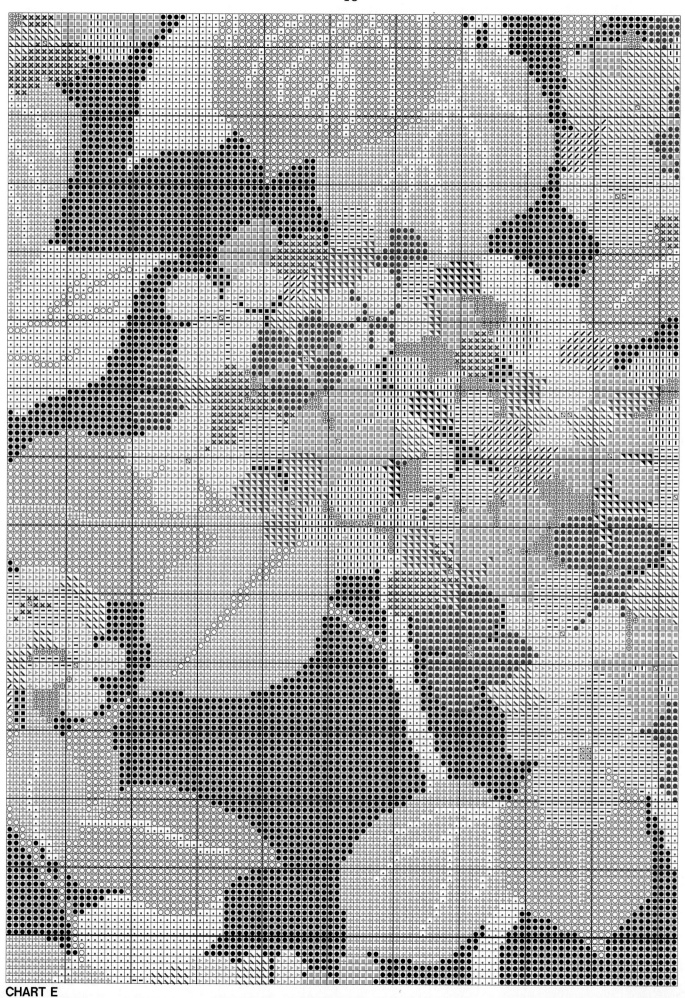

CHART E

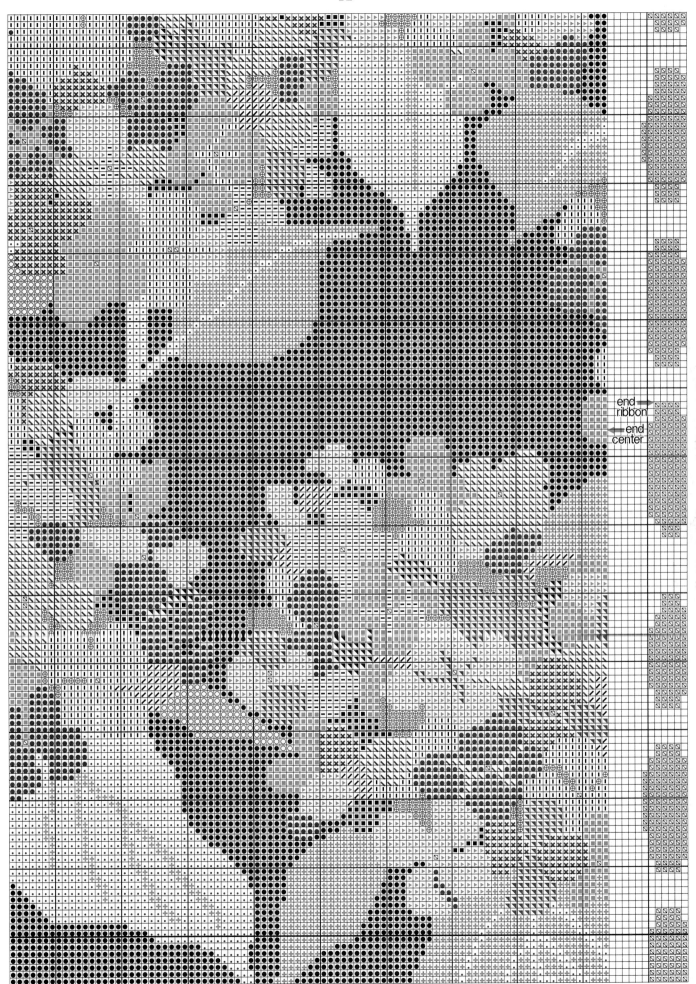

end ribbon
end center

CHART F

PERENNIAL ENJOYMENT

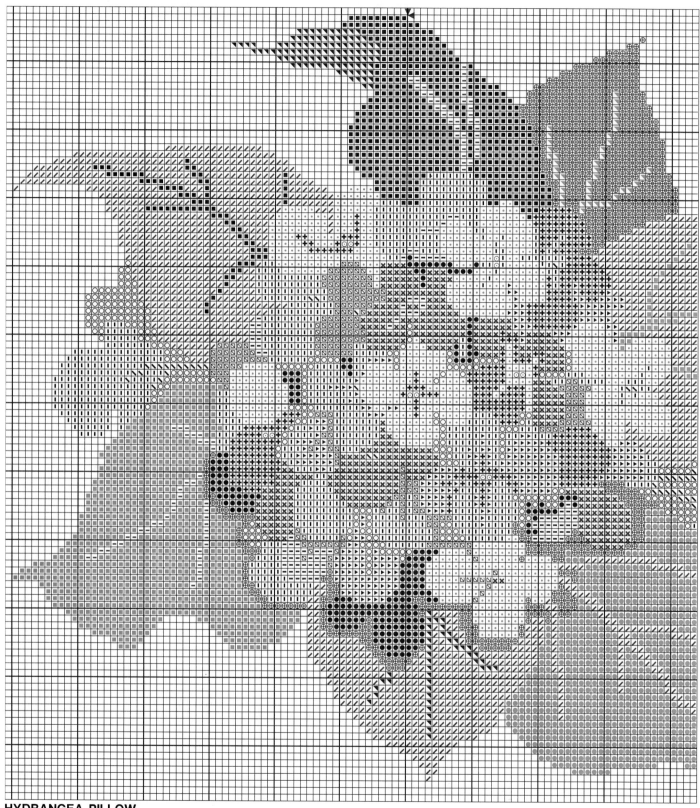

HYDRANGEA PILLOW

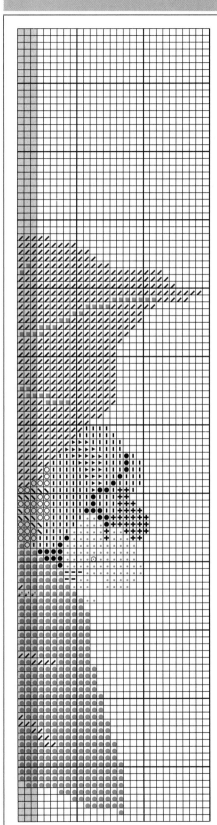

1 Square = 1 Stitch

Hydrangea Rug And Pillow

Shown on pages 28 and 29.

Finished size of rug is 37x51 inches.
Finished size of pillow is 14x14 inches, excluding ruffle.

MATERIALS
For the rug
41x55 inches of 10-count canvas
39x53 inches of cotton fabric for backing; 5½ yards of bias tape
For the pillow
18-inch square of 10-count canvas
1 yard of fabric for backing and ruffle, 60 inches of narrow cotton cording, and 60 inches of 1-inch-wide bias binding to cover cording for the pillow as shown (optional)
For both projects
Paternayan 3-strand yarn in colors and number of yards listed in () on the color key
White paper tape
Tapestry needle

COLOR KEY
▫ Tan 643 (17)
◉ Periwinkle 341 (5)
◣ Light Green 612 (4)
⊠ Light Gray Blue 514 (9)
◩ Pale Green 604 (2)
▢ Light Olive 652 (17)
▣ Green 631 (15)
◪ Teal 522 (1)
▱ Lime 670 (2)
Ⅰ Lavendar 333 (20)
⊞ Purple Gray 563 (10)
⊟ Medium Purple 342 (4)
▷ Light Purple Blue 343 (7)
◪ Yellow Green 692 (50)
⊕ Brown 641 (17)
▢ Light Periwinkle 344 (19)
◌ Light Blue 584 (1)
◩ Light Grape 313 (5)
◎ Purple 312 (9)
 Black 220 (150)

INSTRUCTIONS
Bind raw edges of canvas with tape to prevent raveling.

Using three strands of yarn, stitch small areas of the design in continental stitch; stitch larger areas of the design and background in basket-weave stitch. Refer to page 24 and 25 for stitch diagrams.

For the rug
The charts are on pages 36–41. For ease in working, photocopy the six pages and tape together charts A, B, and C for the bottom of the rug. Tape Chart D on top of Chart A, Chart E on top of Chart B, and Chart F on top of Chart C. Begin stitching with the bow from Chart B 4¾ inches from the bottom edge and approximately 22½ inches from the right edge of the canvas.

Work the complete chart one time. The pattern then is repeated between the red arrows at the side of Chart C and the blue arrows at the side of Chart F. *Note: The ribbon continues for three rows beyond the central design.*

Turn the chart over and work the ribbon and bow at the bottom of charts A, B, and C in reverse order for the other end of the rug.

Fill in the areas between the center design and ribbon and 3 inches beyond the ribbon (about six rows beyond the bow) with navy blue yarn.

Block the rug to shape.

Trim excess canvas from the rug, leaving a 1½-inch unstitched edging. Machine-stitch bias tape to the canvas edge. Fold the 1½-inch edging under to the back side and tack the bias tape in place. Turn under the edges of the backing fabric 1 inch and blind-stitch the backing to the wrong side of the rug.

For the pillow
Referring to the chart, *left*, begin stitching at the red arrows 3½ inches from the top edge and 9¼ inches from the right-hand edge of the canvas. Fill in the background with black yarn.

Refer to blocking tip box on page 11 to block finished needlepoint; finish pillow as desired.

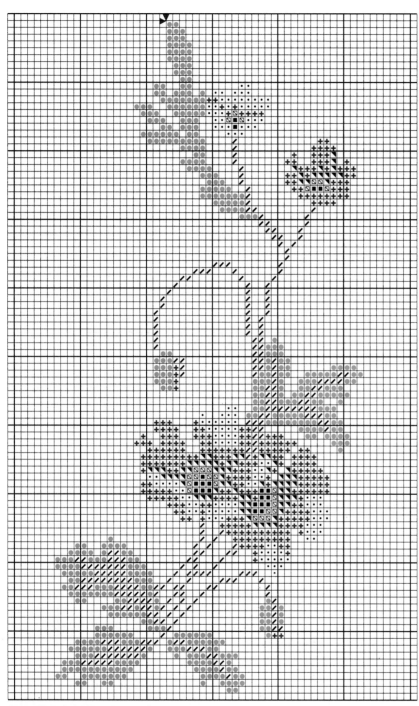

POPPIES EYEGLASS CASE

1 Square = 1 Stitch

COLOR KEY
- ⊡ Peach 854 (3)
- ◥ Dark Red 840 (2)
- � Dark Green 630 (5)
- ⊞ Red 842 (5)
- ■ Dark Gray 221 (1)
- ▦ Green 633 (7)
- ⊠ Blue 541 (1)
- Cream 805 (38)

Poppies Eyeglass Case

Shown on page 31.

Eyeglass case measures 3½x7 inches.

MATERIALS
6½x20 inches of 14-count canvas, or prefinished case designed for needlepoint (available from Alice Peterson Company, 1591 East El Segundo Blvd., El Segundo, CA 90245)
Paternayan 3-strand yarn in the colors and number of yards listed in () on the color key
¼ yard of soft fabric for lining (optional)
Tapestry needle
White paper tape (for handmade case only)

INSTRUCTIONS
For prefinished eyeglass case
The prefinished eyeglass case zips open for easier stitching.

Separate yarn into strands and work with two at a time.

Stitch design in continental stitch; work the background and the back of the case in basketweave stitch. Refer to page 24 for stitch diagrams.

Starting at the red arrows on the chart, *left,* begin stitching ¼ inch from the top and 2¼ inches from the right-hand edge of the case.

When design, background, and back are completed, overcast the top edge to finish it.

When stitching is completed, block the case.

No other finishing is required. If desired, line the case with a soft fabric.

To make your own case
Cut canvas into two pieces, each measuring 6½x10 inches.

Bind raw edges of canvas with tape to prevent raveling.

Starting at the red arrows on the chart, *left,* begin stitching the design for the front of the case 1¾ inches from the top and 3¾ inches from the right-hand edge of the canvas.

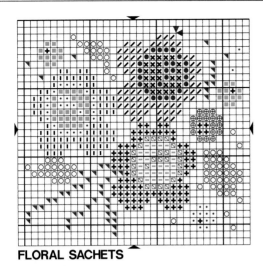

FLORAL SACHETS

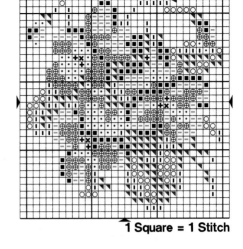

1 Square = 1 Stitch

COLOR KEY

⊞ Yellow 745 ☐ Bright Yellow 743
⊡ Pink 963 ◉ Dark Coral 350
⊠ Peach 353 ◯ Green 3348
⊡ Gold 783 ◥ Dark Green 3345
▣ Rose 603 ☒ Coral 352
⊕ Navy 792 Lavendar 209 (3)
⊡ Red 600

COLOR KEY

⊞ Yellow 743 (3) ◎ Light Green 704
⊡ Green 702 ◥ Dark Green 909
▪ Burgundy 915 ⊟ Periwinkle 340
⊡ Blue 791 ⊕ Dark Periwinkle 333
☒ Salmon 3328

Fill in the background with basket-weave stitches for an overall measurement of 3½x7 inches.

On the second piece of canvas, mark off an area measuring 3½x7 inches for the eyeglass case back. Work the entire area in basket-weave stitch.

Block both finished needlepoint pieces according to blocking instructions on page 11. Trim the canvas around the stitched area on both the front and back, leaving a ½-inch margin of unworked canvas on all sides. Turn the unworked canvas to the back side and hand-stitch in place.

With matching yarn, beginning at the bottom edge, whipstitch the bottom and one side of the case back and front together. Insert a cloth lining if desired and continue joining the other side of the case. Turn the top of the case lining to the inside and whipstitch it to the top edge of the eyeglass case.

Floral Sachets

Shown on page 30.

Each sachet is a 4-inch square, excluding ruffle.

MATERIALS
For each sachet
8x8-inch piece of 10-count canvas
DMC embroidery floss in the colors listed on the color key
¼ yard of fabric for backing, ruffle, or piping, 1 yard narrow cording, and potpourri or fiberfill for sachets as shown (optional)
Tapestry needle
White paper tape

INSTRUCTIONS
Note: One skein of floss is required for each color except for the background. For the background, you need three skeins.

Bind raw edges of canvas with tape to prevent raveling.

Use 12 strands of floss and work the design in continental stitch. Fill in the background with basket-weave stitches. Refer to page 24 and 25 for the stitch diagrams.

For the violet sachet, refer to the chart, *above right,* and begin stitching at the red arrows 2½ inches from the top and 3¼ inches from the right-hand edge of the canvas.

For the rose sachet, refer to the chart, *above left,* and begin stitching at the red arrows 2½ inches from the top and 3¼ inches from the right-hand edge of the canvas.

Refer to the blocking tip box on page 11 to return the stitched piece to shape.

Finish the sachets as desired; the violet sachet shown has a narrow piped edge and the rose sachet has 1½-inch double ruffles.

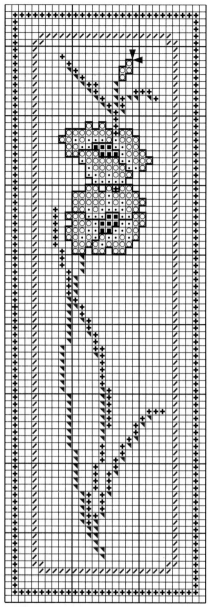

BOOKMARK 1 Square = 1 Stitch

COLOR KEY
⊡ Dark Peach 351
◨ Dark Gold 680
☑ Teal 943
⊞ Gold 676
▣ Yellow 742
◻ Light Peach 353
 Black–Brown 3021

Bookmark

Shown on page 31.

Finished size is 2¼ x 6¼ inches.

MATERIALS
Two 4¼x8¼-inch pieces of ecru-
 colored perforated paper
1 skein *each* of DMC
 embroidery floss colors listed
 on the color key
Tapestry needle
Scissors
White paper tape

INSTRUCTIONS
 Perforated paper can be pur-
chased at most crafts and needle-
work stores. Notice the "right"
side of the paper. It is the side that
feels and looks the smoothest.
Take care when stitching to avoid
tearing the paper; do not pull the
stitches too tight.
 Bind the edges of the paper
with tape to prevent catching the
floss as you work.
 Starting at the red arrows on
the chart, *left*, begin stitching 1⅝
inches from the top edge and 1⅞
inches from the right-hand edge
of the paper.
 Using three strands of floss for
the design and borders, and two
strands for the backstitching
around the flowers, work the en-
tire design and the teal border in
continental stitch. Refer to page
24 and 25 for stitch diagrams.
(Do not work the outer gold bor-
der at this time.)

 TO FINISH: Place the wrong
side of the unworked piece of per-
forated paper atop the back side
of the stitched bookmark. Line up
the holes of both pieces of paper.
Work the outside gold border go-
ing through holes on both pieces
of perforated paper. This will join
the back and front and will con-
ceal the back side of the stitched
design.
 Cut away the excess paper,
leaving two unstitched holes be-
yond the gold border.

Wildflower Pillows

Shown on pages 32 and 33.

Finished size of each pillow, ex-
cluding ruffles, is approximately
18x22 inches.

MATERIALS
For each pillow
22x26 inches of 5-count
 needlepoint canvas
Paternayan 3-strand yarn in the
 colors and number of yards
 listed in () on the color key
1½ yards fabric for backing and
 ruffle, 2½ yards of ⅜-inch-
 diameter cording, and 2½
 yards of 3-inch-wide brown
 bias fabric stripping for
 pillows as shown (optional)
Tapestry needle
White paper tape
Polyester fiberfill (optional)

INSTRUCTIONS
 Bind raw edges of canvas with
tape to prevent raveling.
 Refer to pages 24 and 25 for
stitch diagrams.
 Following the charts on pages
47–51, use six strands of yarn
and continental stitches to work
the flower designs. Locate the
centers of the graph and the can-
vas; begin stitching there.
 Using basket-weave stitches
and light celery-colored yarn, fill
in the background to complete a
rectangle that measures approxi-
mately 18x22 inches.
 Block the stitchery referring to
blocking tips on page 11.
 Finish needlepoint as pillows
or as desired.

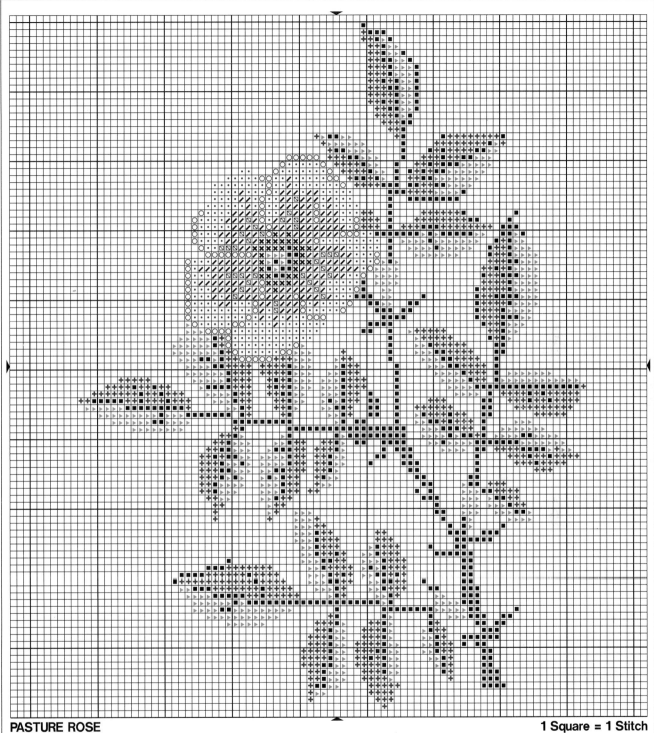

PASTURE ROSE

1 Square = 1 Stitch

COLOR KEY

▣ Brown 450 (20)	◎ Dark Rose 910 (3)	◩ White 261 (1)
⊞ Spring Green 632 (20)	⊡ Rose Pink 904 (8)	⊠ Yellow 716 (1)
▷ Pine Green 662 (20)	⊿ Dusty Pink 914 (5)	Celery Cream 666 (178)

PERENNIAL ENJOYMENT

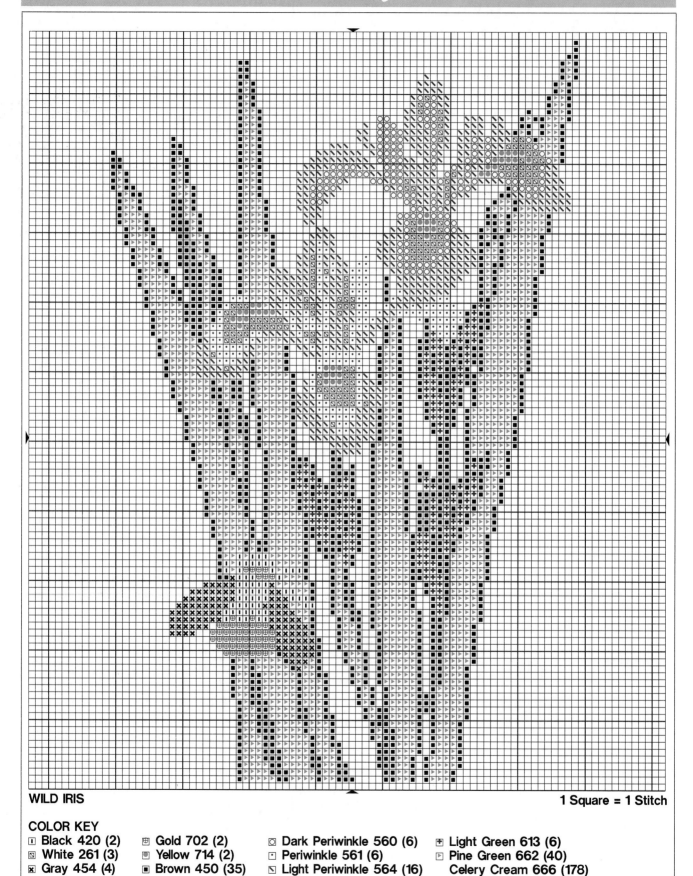

WILD IRIS

1 Square = 1 Stitch

COLOR KEY

⊡ Black 420 (2)	⊞ Gold 702 (2)	◎ Dark Periwinkle 560 (6)	⊞ Light Green 613 (6)
⊡ White 261 (3)	▣ Yellow 714 (2)	⊡ Periwinkle 561 (6)	▷ Pine Green 662 (40)
⊠ Gray 454 (4)	■ Brown 450 (35)	◣ Light Periwinkle 564 (16)	Celery Cream 666 (178)

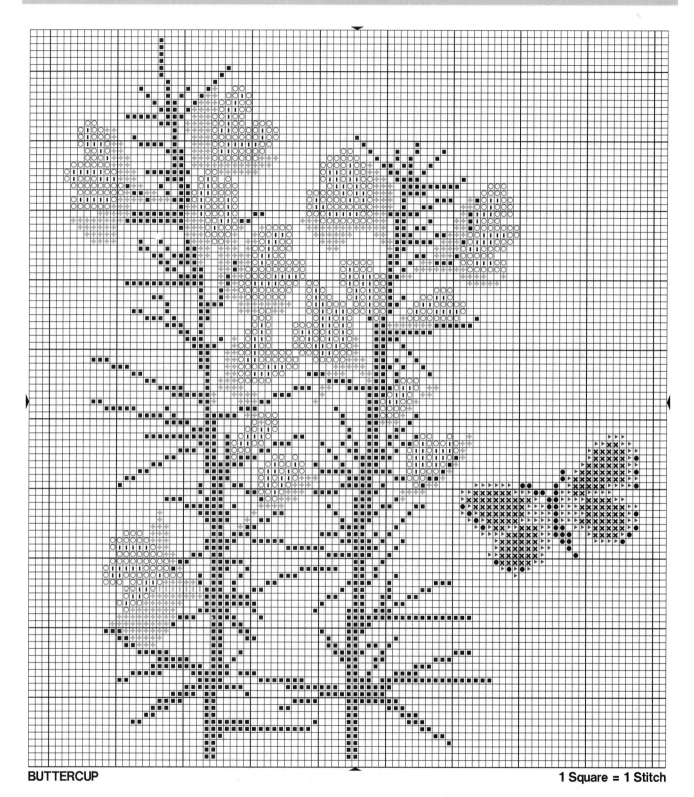

BUTTERCUP

1 Square = 1 Stitch

COLOR KEY

▣ Black 420 (2)	◌ Mustard 712 (20)	⊠ Light Periwinkle 564 (5)
▷ Dark Periwinkle 560 (5)	⊡ Yellow 714 (10)	⊞ Loden Green 691 (14)
	▪ Brown 450 (35)	Celery Cream 666 (178)

PERENNIAL ENJOYMENT

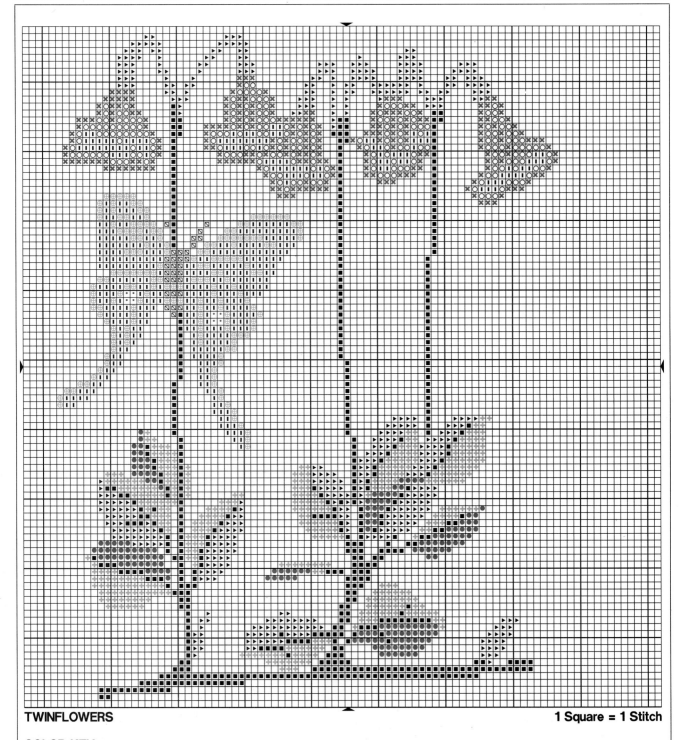

TWINFLOWERS　　　　　　　　　　　　　　　　　　　　　　　　　**1 Square = 1 Stitch**

COLOR KEY

⊠ Pink 905 (8)	⊡ Dark Teal 522 (1)	▣ Brown 450 (18)	⊞ Spring Green 632 (13)
◎ Dusty Pink 915 (8)	⊡ White 261 (15)	▷ Pine Green 662 (13)	Celery Cream 666 (178)
▦ Teal 523 (6)	◩ Taupe 453 (1)	◙ Hunter Green 610 (6)	

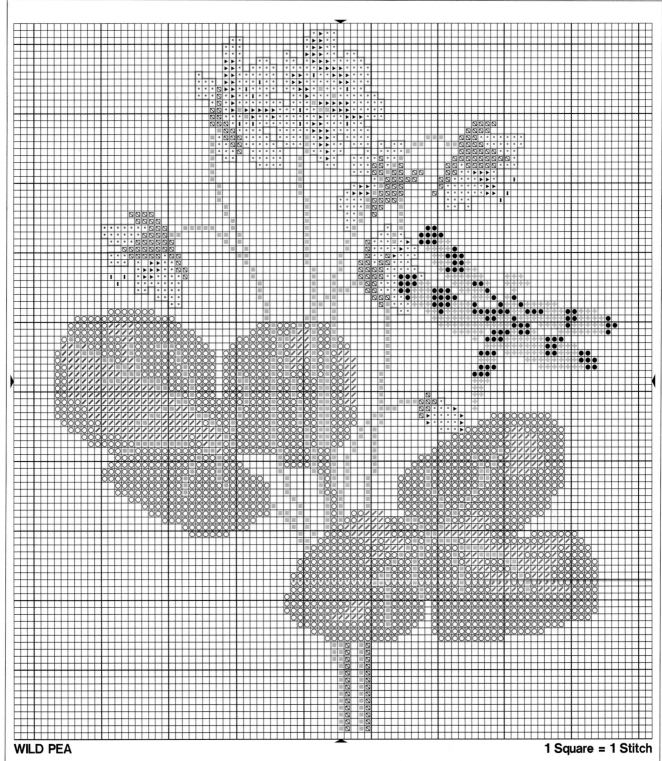

WILD PEA

1 Square = 1 Stitch

COLOR KEY

⊞ Taupe 453 (8)

▣ Gold 801 (1)

▨ Spring Green 632 (15)

▶ Dark Coral 953 (4)

▨ Loden Green 691 (45)

▦ Brown 450 (15)

⊡ Light Pink 946 (10)

◎ Pine Green 662 (45)

⦿ Dark Taupe 453 (4)

Celery Cream 666 (178)

HOME SWEET HOME SAMPLER

FOR YEAR-ROUND SPLENDOR

Samplers, for centuries creative showcases for stitchers of all ages, speak eloquently of home and hearth. On these endearing slates, pioneer girls first learned needle arts, embellishing samplers with alphabets, numerals, floral motifs, and sentimental sayings. This sampler's heartfelt message carries on that tradition with a twist. It's a needlepoint adaptation worked on perforated paper.

Firmly rooted in the home decorative arts of Europe, samplers became a stitcher's staple in the New World. American designs often were elaborate, incorporating family trees, pictorials, and albeit rare, globe-shaped maps. They commonly were improvised cross-stitch patterns on linen, linsey-woolsey, or gauzelike tiffany.

Stitched in pastel embroidery floss, this contemporary sampler, *right*, is inspired by a traditional flower-and-verse theme. Instead of fabric, the design is worked on a 13x18-inch piece of ecru perforated paper. Finished, the needlepoint design area only is 9½x14 inches.

Cover paper edges with white paper tape after attaching the piece to stretcher strips. Using a tapestry needle and six strands of floss, work each square in continental stitch following the chart on pages 54 and 55. Mat and frame the sampler as desired for wall or tabletop display.

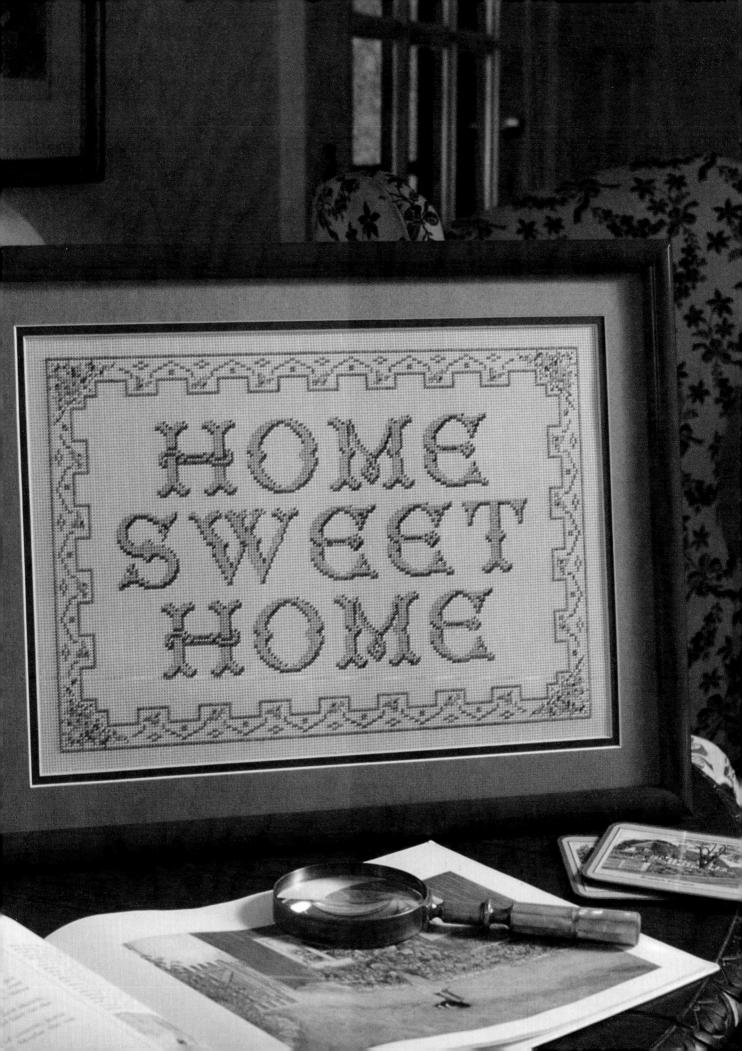

HOME SWEET HOME SAMPLER

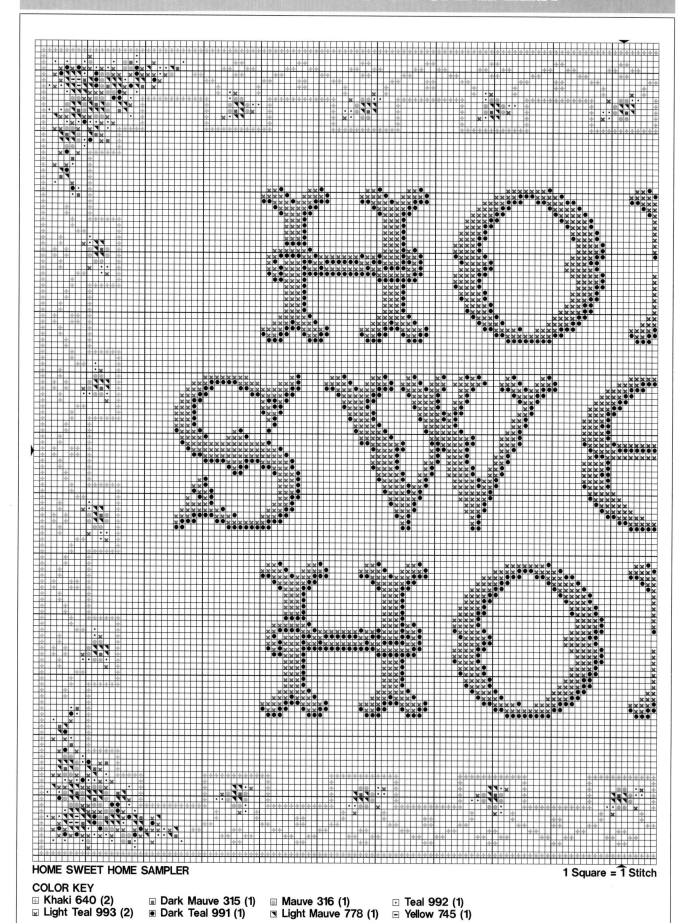

HOME SWEET HOME SAMPLER

1 Square = 1 Stitch

COLOR KEY

⊞ Khaki 640 (2)	⊡ Dark Mauve 315 (1)	⊟ Mauve 316 (1)	⊡ Teal 992 (1)
⊠ Light Teal 993 (2)	◉ Dark Teal 991 (1)	◥ Light Mauve 778 (1)	⊟ Yellow 745 (1)

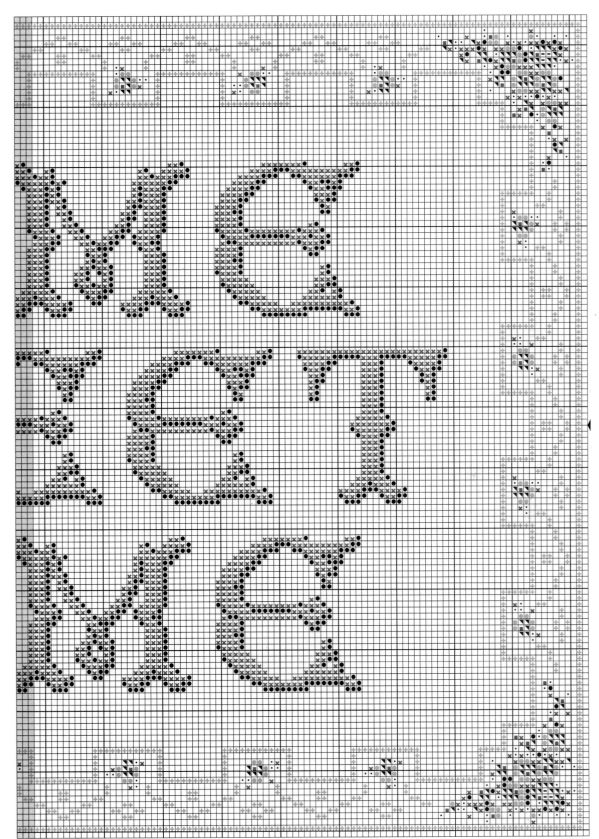

1 Square = 1 Stitch

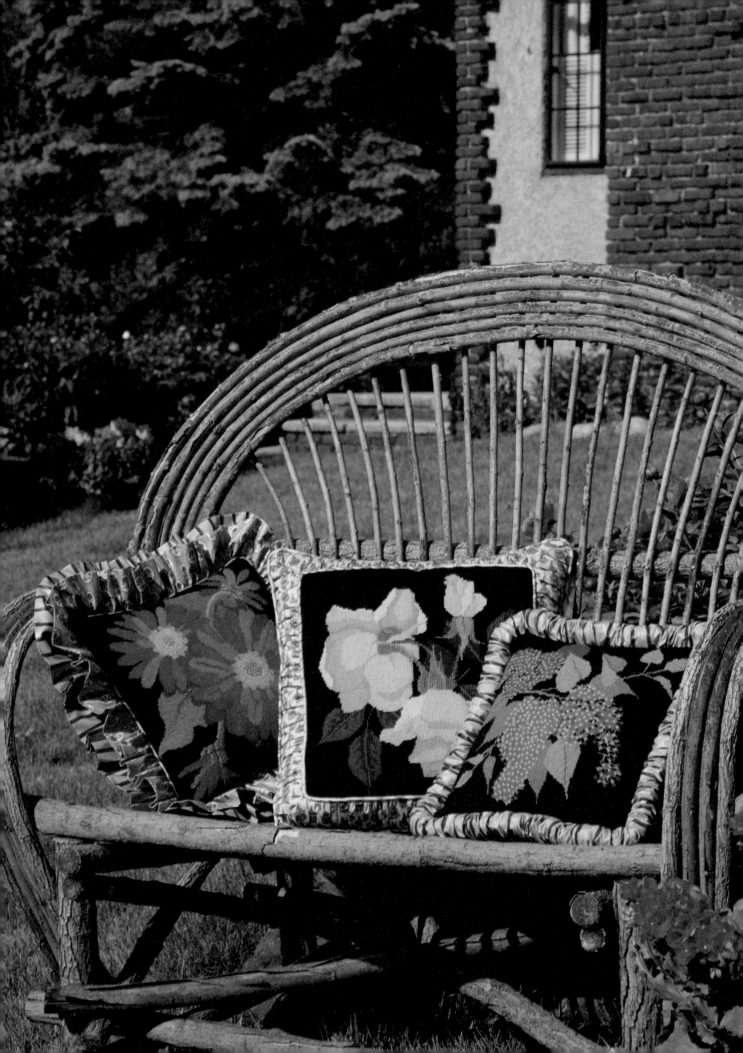

A PROFUSION OF BLOOM

FOR A COUNTRY COTTAGE

For the medieval tapestry maker, brilliant and fragrant inspiration waited just beyond the cottage door. Free-spirited gardens of the time simply celebrated the natural beauty of flowers, planted seemingly at random in a kaleidoscope of colors. The early needle artist let nature cue the motifs that embellished the stitchery. In this chapter, you'll find a bouquet of needlepoint projects, from pillows to a buttons-and-bows doll, fresh from the garden.

With dashes of bright colors and the unspoken promise of spring, floral needlepoint accessories can turn your home's interiors into an all-season tapestry.

The beautiful trio of accent pillows, *left*, plucks all-time garden favorites—the rose, the lilac, and the zinnia—for design themes. The pillows' striking black backgrounds add a dramatic contrast to the bright hues of the featured blooms. Work the dominant floral motifs in continental stitch. Each of the finished needlepoint pillow tops measures 14 inches square, excluding the ruffle. Each is done in Persian wool yarn on an 18-inch square of 10-mesh needlepoint canvas. Block the completed tops and assemble as pillows with a gathered or layered fabric ruffle. Instructions begin on page 65.

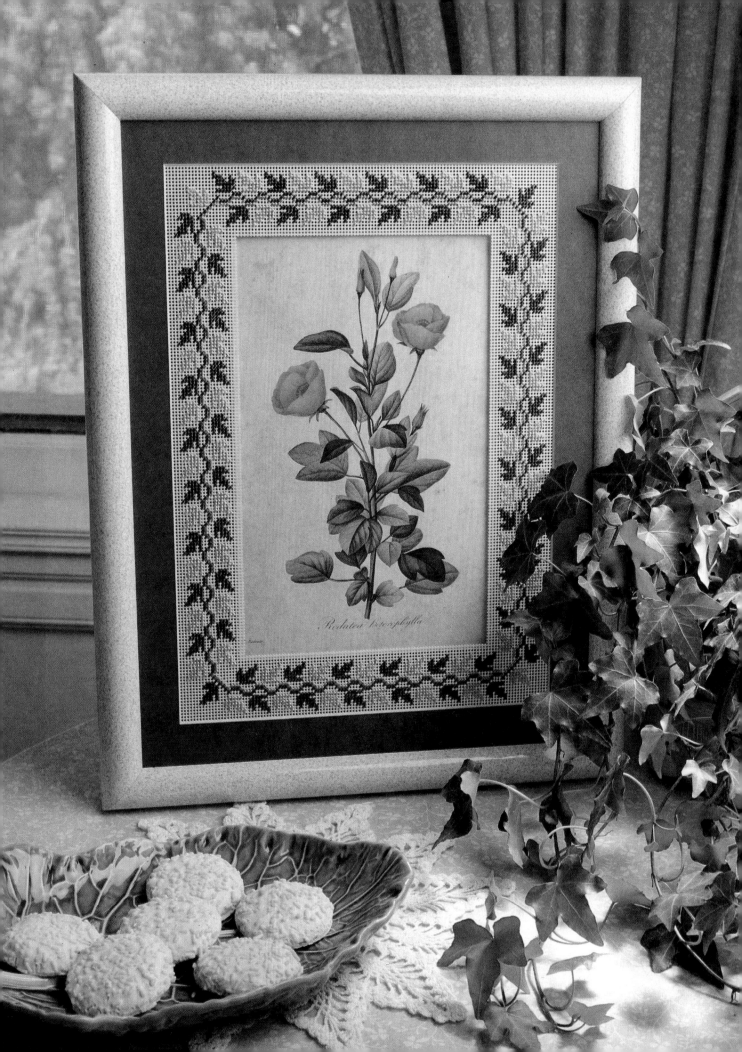

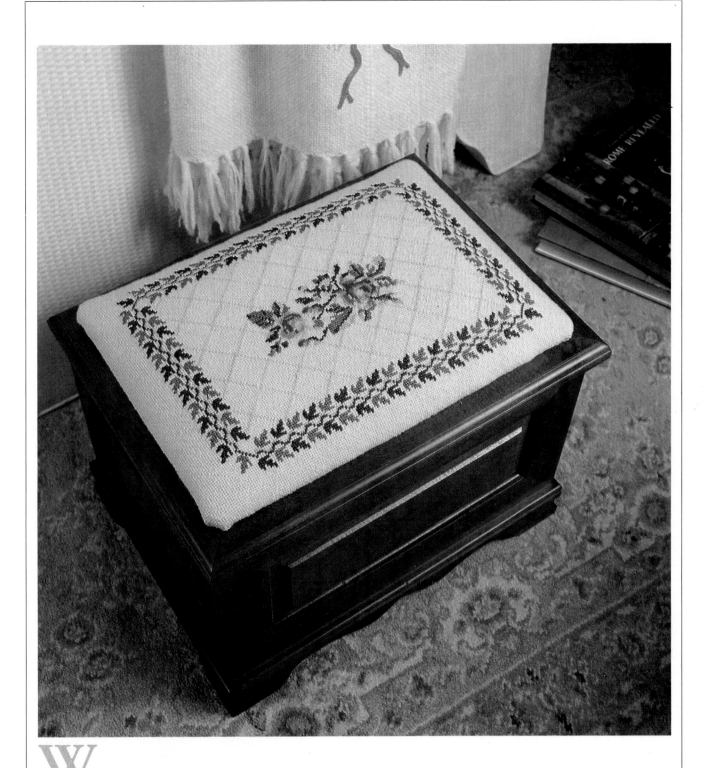

With a charming leaf-and-vine motif, the needlepoint picture mat, *opposite,* is fitting for a favorite botanical print.

Worked in embroidery floss on perforated paper, this mat's finished opening is 5¾x9 inches, but you can adjust the pattern to frames of other sizes.

A 10½x15-inch topper, stitched in a delicate rose-trellis design, imparts an heirloom look to the handy sewing chest, *above.* Instructions begin on page 65.

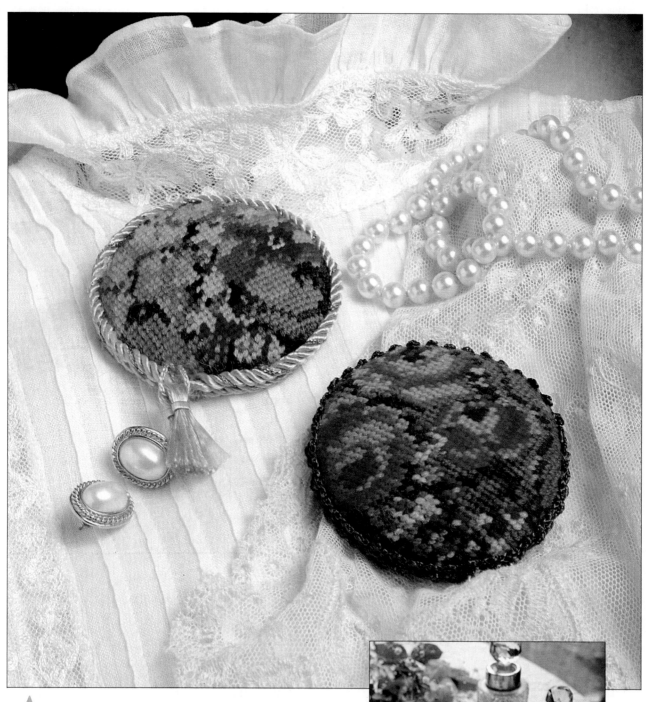

All dressed up in needlepoint finery, the old-fashioned doll, *opposite,* measures 12 inches tall and is worked in embroidery floss on canvas. With such endearing details as fringed bangs and fancy trims of pearls, lace, and ribbon, she's sure to bring a smile as a room accent or as a gift for someone special.

From two flowers-in-the-round designs, you can create the elegant pins, *above,* and the pretty topper for the crystal dresser jar, *right.* Instructions begin on page 69.

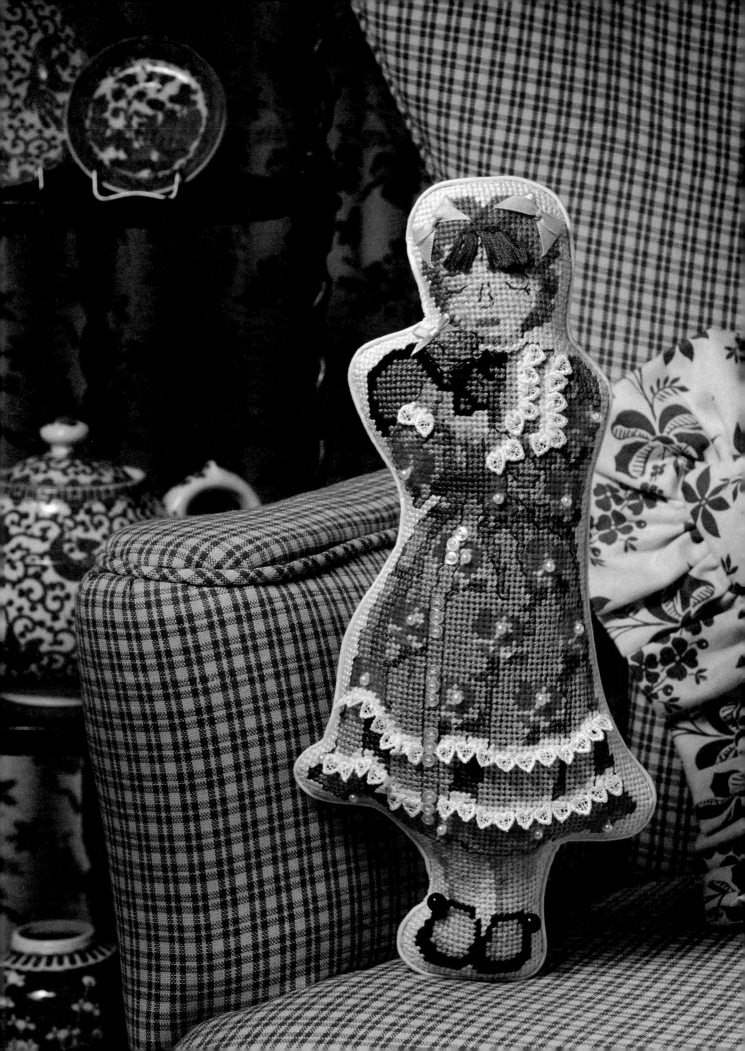

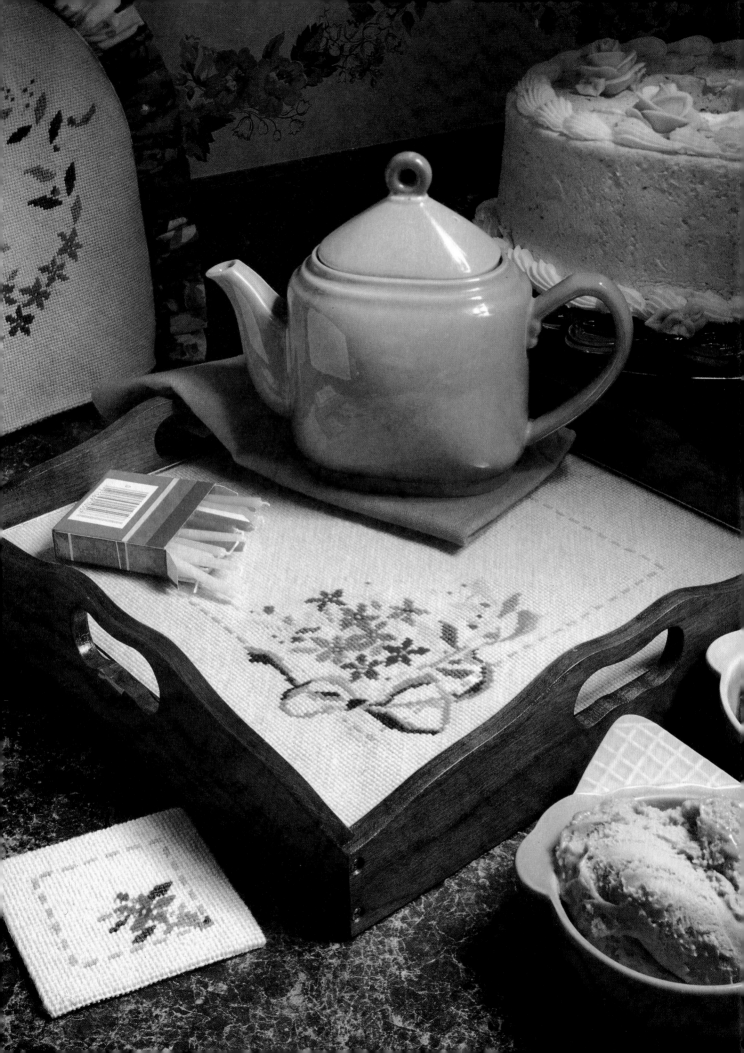

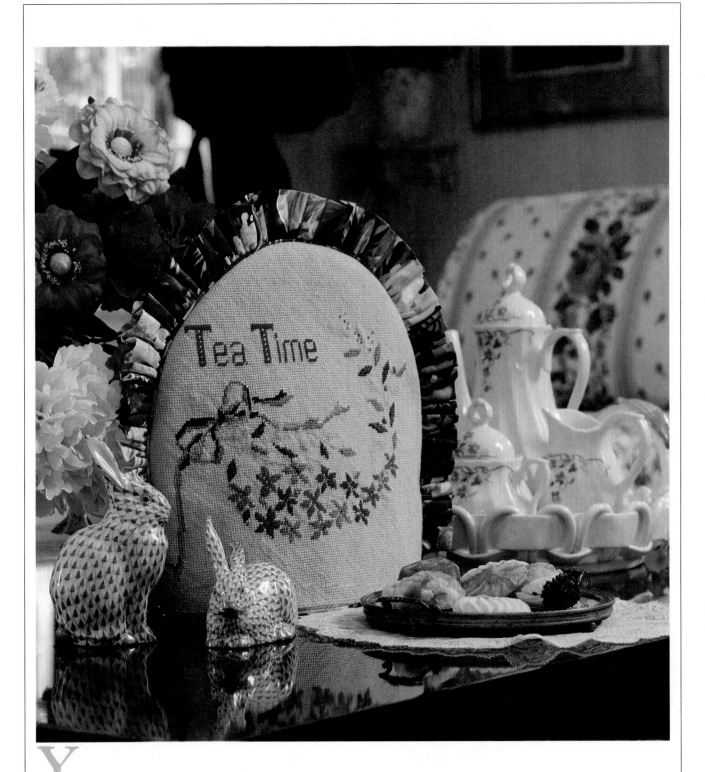

Your tea parties will long be remembered for their cottage flair. The tea cozy, *above*, will keep the pot warm while you walk your friends through the garden. Its bright blossoms and bow are stitched on 14-count canvas. Instructions also are provided to make a tea cozy to fit the shape of your own teapot.

The handsome tray insert and coasters, *opposite*, complete the delightful serving set. By adjusting the dashed border, the pattern will fit almost any tray insert.

Instructions begin on page 74.

A PROFUSION OF BLOOM

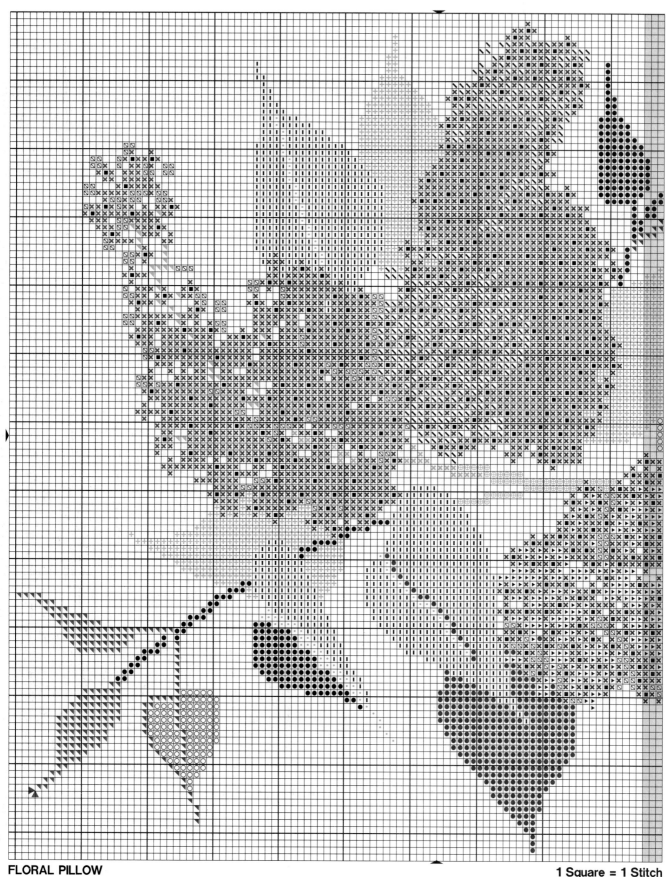

FLORAL PILLOW

1 Square = 1 Stitch

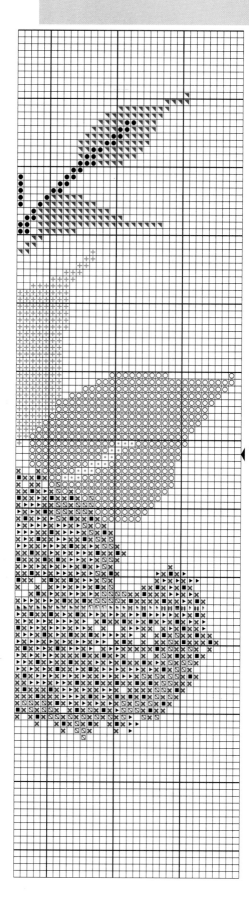

Floral Pillows

Shown on pages 56 and 57.

Finished size of each pillow top is 14 inches square, excluding the ruffles.

MATERIALS
18-inch square of 10-count
 canvas for each pillow
Paternayan 3-strand yarn in
 colors and number of yards
 listed in () on the color keys
White paper tape
Tapestry needle
Polyester fiberfill
Backing and trim fabric
 (optional)

INSTRUCTIONS
The lilac pillow chart is *left*, the rose pillow chart is on pages 66 and 67, and the zinnia pillow chart is on pages 68 and 69.

Bind raw edges of canvas with tape to prevent raveling.

Use three strands of yarn.

Begin stitching the lilac design 3¼ inches from the top and 4¼ inches from the left side of the canvas. Begin the rose design 4½ inches from the top and 3 inches from the right side of the canvas. Begin the zinnia design 2⅝ inches from the top and 2⅝ inches from the right side of the canvas. (The starting place for stitching is marked on each chart with two red arrows.)

COLOR KEY
◥ Light Green 663 (2)
◼ Yellow 704 (11)
▶ Light Periwinkle 343 (9)
◨ Dark Periwinkle 340 (7)
⬚ Yellow Green 693 (12)
⊞ Spring Green 631 (16)
⬚ Dark Spring Green 630 (1)
⊠ Dark Pine 662 (2)
◎ Dark Yellow Green 692 (10)
◣ Lilac 333 (8)
⊞ Medium Brown 434 (1)
◥ Lime Green 670 (8)
⊠ Periwinkle 342 (47)
◉ Gray Green 612 (5)
◉ Dark Olive 651 (8)
 Black 220 (152)

Work the designs in continental stitch and the background in basket-weave stitch with black yarn. Stitch diagrams appear on pages 24 and 25.

Follow blocking tips on page 11 to return the canvas to original shape.

Assemble pillows as desired.

Leaf and Vine Picture Mat

Shown on page 58.

Finished mat opening measures 5¾x9 inches; the outside edges measure 11x14¼ inches.

MATERIALS
11½x14¾ inches of ecru
 perforated paper
DMC embroidery floss in the
 colors listed on the color key
Embroidery or tapestry needle
Artist's stretcher strips (when
 assembled inside opening to
 measure at least 13x16
 inches)
White paper tape
Sewing scissors

INSTRUCTIONS
Refer to the chart on pages 70 and 71 and work only the vine border. If necessary, adjust the design provided to make the picture mat fit another size frame.

Assemble stretcher strips and use as a needlepoint frame. Staple the edges of paper to the top of frame to hold the paper taut. Cover raw edges of paper with tape to prevent tearing.

If more than one skein of floss is used in any color, the amount needed is indicated in parentheses following the color number.

Use all six strands of floss and stitch over one square of paper. Work in continental stitch. Begin stitching at the top right-hand corner, 1½ inches from the side and top of the paper. (The starting point is marked with red arrows.)

Use sharp scissors to remove the center mat opening.

A PROFUSION OF BLOOM

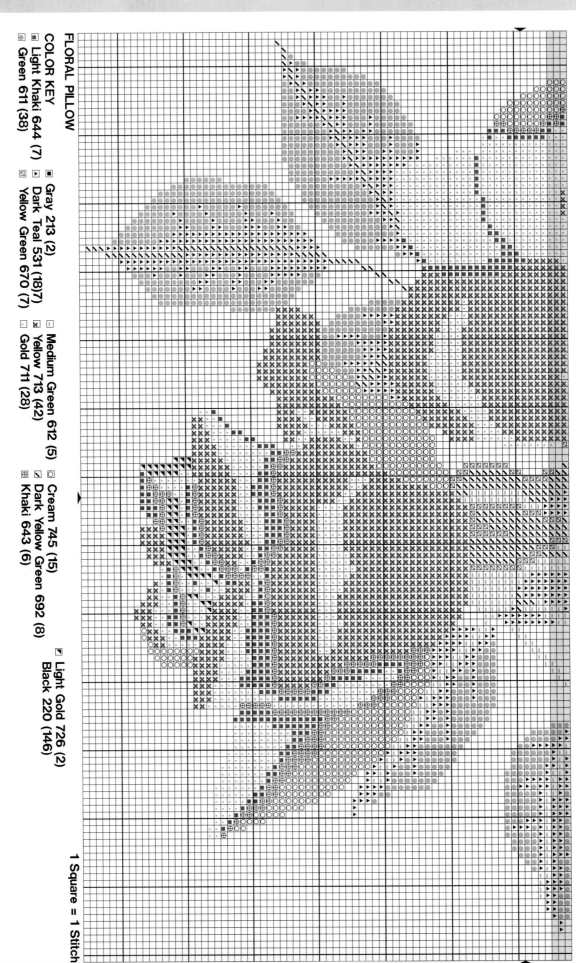

FLORAL PILLOW

COLOR KEY

- ▣ Gray 213 (2)
- ◪ Light Khaki 644 (7)
- ▨ Green 611 (38)
- ▣ Medium Green 612 (5)
- ▸ Dark Teal 531 (187)
- ▨ Yellow Green 670 (7)
- ▢ Cream 745 (15)
- ▧ Yellow 713 (42)
- ▣ Gold 711 (28)
- ◪ Light Gold 726 (2)
- ◪ Dark Yellow Green 692 (8)
- ⊞ Khaki 643 (6)
- ◪ Black 220 (146)

1 Square = 1 Stitch

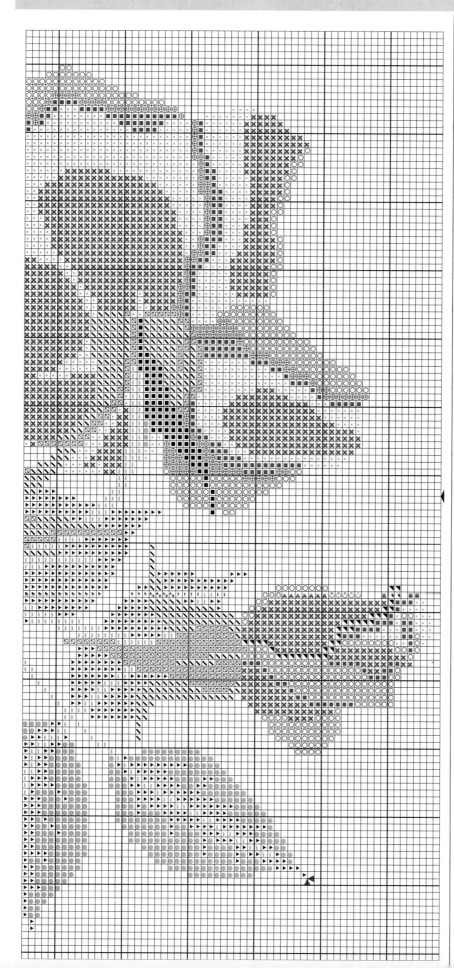

Sewing Chest
With Rose Trellis Lid

Shown on page 59.

Finished size of needlepointed top is 10½x15 inches. (Work the background to a size of 12½x17 inches to allow for tucking under padded top.)

MATERIALS

13x17-inch piece of 14-count canvas
Paternayan 3-strand yarn in the colors and number of yards listed in () on the color key
White paper tape
Tapestry needle
Sewing chest from Plain n' Fancy, Box 357, Mathews, VA 23109.

INSTRUCTIONS

Fold the canvas around the surface that will be covered to determine how much background you will need to stitch. Allow an additional 1 inch of canvas on all four sides for mounting. The more padded the top, the more background that will be needed to completely cover it.

Note: To custom-fit the size of the covering to a box other than the model shown, adjust the trellis design accordingly.

Bind raw edges of canvas with tape to prevent raveling.

Refer to the chart on pages 70 and 71. Use two strands of yarn to work this design.

Begin stitching 2½ inches from the top and 3 inches from the right side of the canvas.

Work all design areas in continental stitch and fill the background areas in basket-weave stitch with pink yarn.

Follow blocking instructions on page 11 to return canvas to its original shape.

MOUNTING AND ASSEMBLY: Unscrew and remove the lid insert. Center the stitchery over insert. Fold excess fabric to the back side of insert and staple. Screw insert back onto the lid.

FLORAL PILLOW

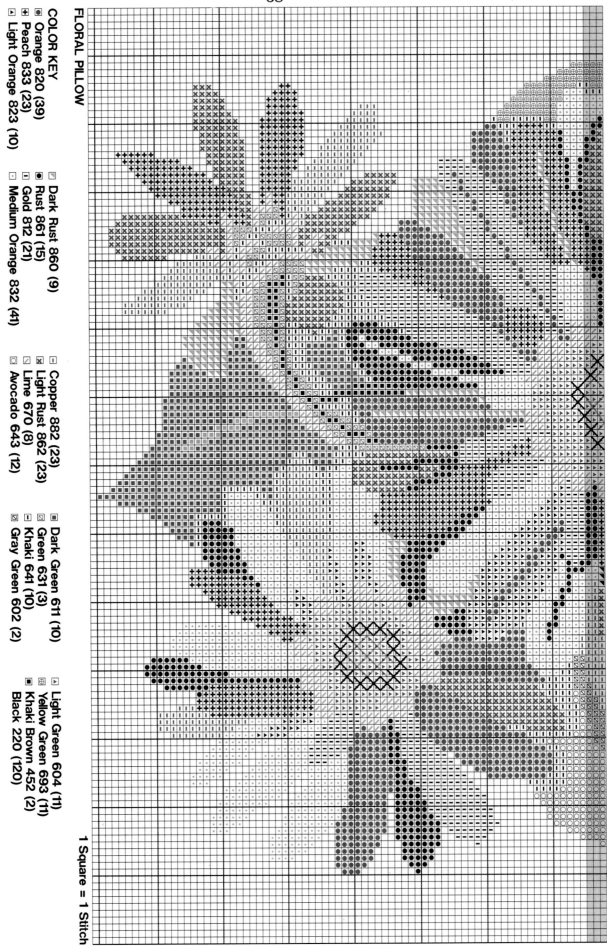

COLOR KEY

- ☑ Dark Rust 860 (9)
- ◉ Rust 861 (15)
- ⊞ Peach 833 (23)
- ▣ Light Orange 823 (10)
- ⊡ Orange 820 (39)
- ◉ Gold 812 (21)
- ⊡ Medium Orange 832 (41)

- ⊡ Copper 882 (23)
- ⊠ Light Rust 862 (23)
- ☑ Lime 670 (8)
- ☑ Avocado 643 (12)

- ■ Dark Green 611 (10)
- ⊠ Green 631 (3)
- ⊡ Khaki 641 (10)
- ⊠ Gray Green 602 (2)

- ▶ Light Green 604 (11)
- ⊕ Yellow Green 693 (11)
- ■ Khaki Brown 452 (2)
- ○ Black 220 (120)

1 Square = 1 Stitch

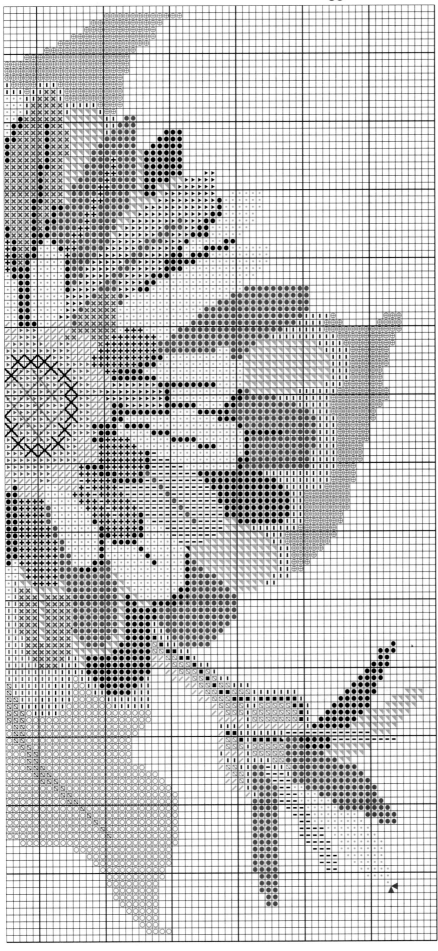

Needlepoint Doll

Shown on page 61.

Finished size of doll is 12 inches tall.

MATERIALS
9x16 inches of 12-count canvas
1 skein each of DMC embroidery floss in the colors listed on the color key, except 2 skeins of blue (794)
¼ yard of fabric for backing and cording
1 yard of narrow cord
16 inches of ¼-inch-wide lace trim
8 inches of ¼-inch-wide satin ribbon
4 inches of ⅛-inch-wide satin ribbon
¾ inch of tiny pearl trim
Sixteen 4mm seed pearls
Two 8mm round black buttons
Fifteen 5mm white buttons
White paper tape
Tapestry needle
Fiberfill

INSTRUCTIONS
Bind raw edges of canvas with tape to prevent raveling.

Working from the chart on page 72, begin stitching the doll at the top of the hair, centered 2 inches below the top of the canvas. Using six strands of floss, work the entire doll in continental stitch.

Using two strands of floss, add backstitching in dark blue to the dress, in black-brown for the facial features, and in black for the cat's face.

Use dark brown floss to fringe bangs. Make overhand knots with six strands of floss, coming through one stitch at a time.

Using ecru floss, add additional rows of stitching for ½ inch around the entire outline of the doll.

When the needlepoint is completed, hand-stitch lace, pearls, buttons, and bows in place. Refer to the photograph on page 61 for guidance.

continued

A PROFUSION OF BLOOM

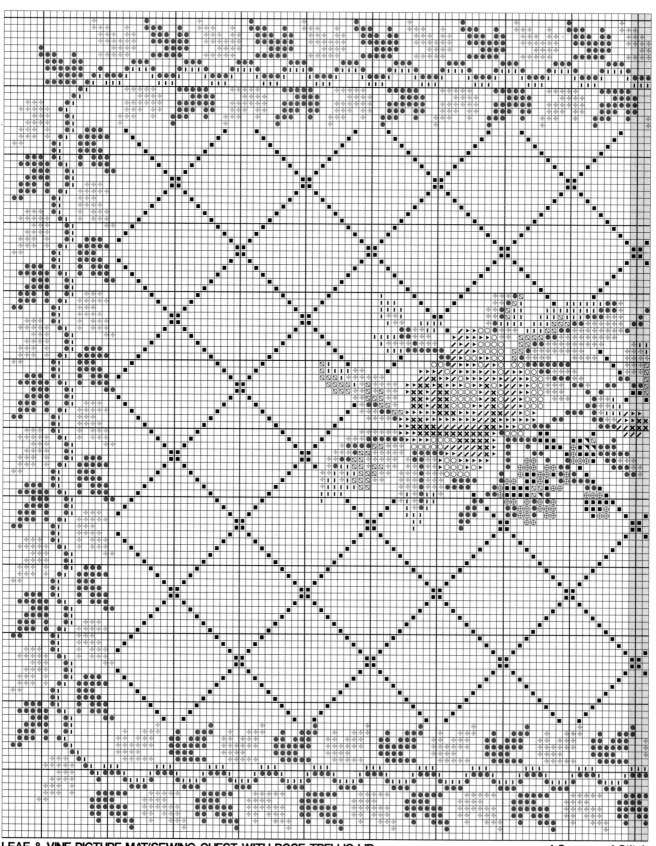

LEAF & VINE PICTURE MAT/SEWING CHEST WITH ROSE TRELLIS LID

1 Square = 1 Stitch

COLOR KEY

⊡ Light Green 664 (9)	⊠ Red 950 (3)	⊡ Light Yellow 727 (1)	◪ Strawberry 952 (2)	
⊟ Yellow 724 (1)	◙ Green 662 (13)	◥ Gold 715 (3)	■ Light Blue 344 (9)	⊞ Dark Green 661 (21)

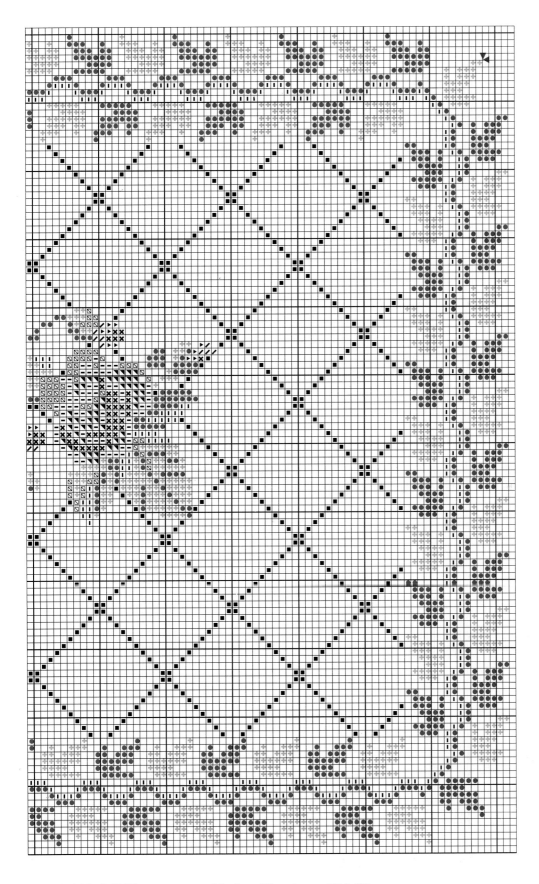

⊞ **Periwinkle 341 (2)**
▣ **Medium Strawberry 954 (2)**
◎ **Light Strawberry 947 (2)**
Light Pink 935 (157)

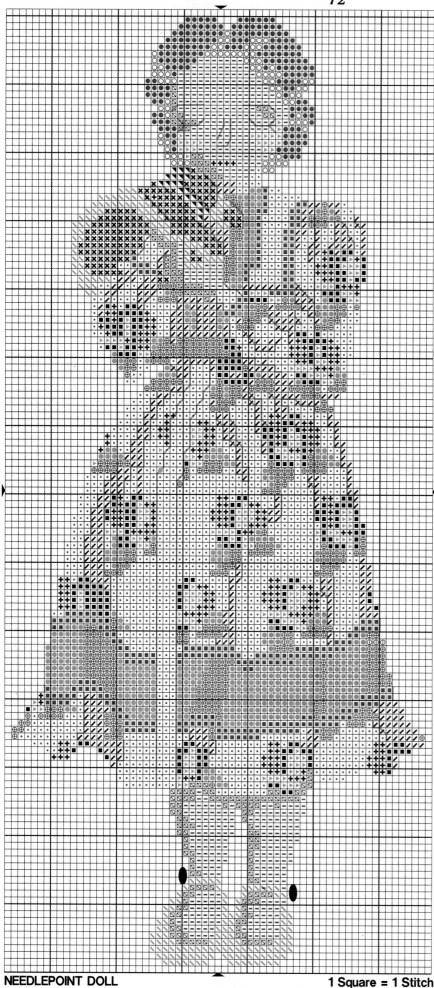

NEEDLEPOINT DOLL

1 Square = 1 Stitch

ASSEMBLY: Trim the needle-point canvas ½ inch beyond the outer row of stitching.

From the fabric, cut a backing the same size and shape as the needlepoint front.

Cut bias strips of fabric to cover the cording.

Stitch the bias strips together and sew them over the cable cord using a zipper foot. Pin the piping along the edges of the stitched canvas so that it is just inside the first row of needlepoint stitches. Baste in place.

With right sides together, pin the needlepoint front to the fabric back, matching raw edges. With a zipper foot, stitch just inside the first row of stitches, sewing as close to the piping as possible. Leave the bottom open.

Turn the doll right side out to check that the piping is in place and no bare canvas is exposed in the seams. Turn it wrong side out and clip the curves.

Turn the doll right side out again and stuff it firmly with fiberfill. Slip-stitch the opening closed.

COLOR KEY
⊞ Dark Rose 309
⊟ Flesh 754
◩ Medium Blue 793
▷ Pink 963
⊠ Dark Flesh 758
▪ Rose 961
⊕ Dark Green 561
◉ Brown 435
◣ Gray 647
◺ Black 310
⊠ Dark Gray 646
◙ Mint 563
◍ Dark Brown 433
⊡ Blue 794 (2)
▣ White
 Ecru
 Dark Blue 791
 Black 310
 Black-Brown 3021

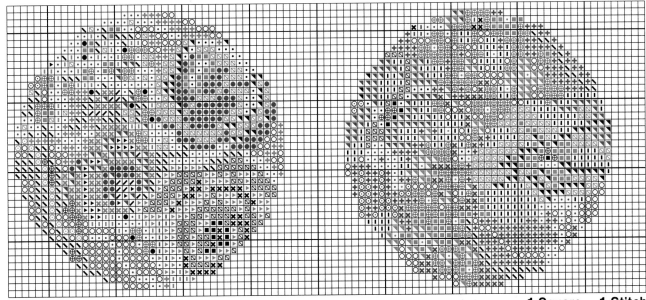

FLORAL PINS AND DRESSER JAR

1 Square = 1 Stitch

COLOR KEY
- ⊞ Green 8414
- ◎ Light Green 8413
- ⊡ Dark Green 8415
- ◉ Dark Blue Green 8416
- ◣ Bright Green 7897
- ⊞ Light Blue 7800
- ▣ Purple 7794
- ◉ Light Purple 7895
- ◩ Dark Burgundy 8124
- ▣ Burgundy 8124A
- ◉ Pink 7151
- ◩ Rose 7153
- ⊡ Dark Rose 7155

- ◥ Fuchsia 7685
- ⊡ Dark Red 8126
- ▶ Red 8103
- ⊠ Pink Red 7106
- ◩ Apricot 7173
- ⊡ Peach 8129
- ⊠ Dark Peach 8128
- ◥ Peach Pink 7103
- ◎ Pink Peach 7104
- ⊞ Gold 7725

DMC Floss
- ⊡ Turquoise 958

COLOR KEY
- ⊞ Light Bright Green 7904
- ◎ Light Green 8413
- ⊡ Dark Green 8415
- ⊠ Dark Evergreen 8409
- ◣ Bright Green 7897
- ⊞ Light Blue 7800
- ▣ Purple 7794
- ◥ Lavendar 7896
- ⊡ Light Pink Peach 7102
- ▣ Burgundy 8124A

- ⊡ Brown 8320
- ◩ Rose 7153
- ⊡ Yellow 7026
- ◥ Fuchsia 7685
- ⊡ Dark Red 8126
- ◩ Apricot 7173
- ⊠ Dark Peach 8128
- ◥ Peach Pink 7103
- ◎ Pink Peach 7104
- ⊞ Gold 7725

Floral Pins And Dresser Jar

Shown on page 60.

Finished diameter of pin is 2½ inches. Jar lid insert measures 2⅝ inches in diameter.

MATERIALS
For both
1 skein each of DMC Médicis 2-ply wool yarn in the colors listed on the color key
White paper tape
Tapestry needle
For one pin
5½x5½ inches of 14-count canvas
2½-inch-diameter button to cover
Glue-on pin back; epoxy glue
For the dresser jar
5½x5½ inches of 16-count canvas
Jar with lid (*Note:* The English lead crystal jar shown on page 61 is available from Anne Brinkley Designs, 21 Ransom Road, Newton Centre, MA 02159.)

INSTRUCTIONS
For the pin
(*Note:* The button used for the pins shown on page 60 is manufactured by William Prym, Inc., and can be purchased through most fabric stores.)

Work directly from either chart, *above.*

Bind raw edges of canvas with tape to prevent raveling.

Use three strands of yarn to work this design.

Begin stitching the design 1 inch down from the center top of the canvas. Work the design in continental stitch.

Follow blocking instructions on page 11 to return the canvas to its original shape.

FINISHING: Remove button shank. Cover button with stitchery following manufacturer's directions. Epoxy pin back to pin.

For the dresser jar
Work directly from either chart, *above.*

Remove the insert from the jar lid; center insert atop the canvas and trace around it. Begin stitching the design in the center of the marked circle.

Using two strands of yarn, work the design area in continental stitch. Fill in the area outside of the design and up to the inside edge of the marked circle in basket-weave stitch with avocado green. Refer to pages 24 and 25 for stitch diagrams.

FINISHING: Block finished needlepoint. Trim excess canvas; cover the insert with the finished needlepoint. Reposition the insert in the lid.

Tea Cozy

Shown on page 63.

Finished tea cozy shown is 11x10½ inches excluding ruffle.

MATERIALS
15-inch square of 14-count canvas
DMC Floralia 3-strand yarn in the colors and number of skeins listed in () on the color key
Tissue paper
¼ yard lining fabric
¼ yard prequilted backing fabric
½ yard cotton print fabric for ruffle (optional)
1¼ yards cording
1¼ yards bias tape to cover cording
¼ yard of fleecing
White paper tape
Tapestry needle

INSTRUCTIONS
Refer to the chart, *right*, to work the tea cozy design.

Use two strands of yarn to work design and background.

Begin stitching the design area of the tea cozy from the center of the chart. Work design in continental stitch.

Using tissue paper, make a dome-shaped pattern big enough to cover half of your teapot (to make the pattern measure over half of the circumference of the tea pot and higher than the actual pot). Cut out two of the shapes from paper; tape them together along the edge and set the paper tea cozy shape over your teapot to make sure you like the size and shape. The cozy should not fit too snugly. Experiment with paper patterns until the correct shape is determined before cutting out fabric or finishing background of the tea cozy front.

Bind raw edges of canvas with tape to prevent raveling.

Mark pattern outline on canvas for tea cozy front, centering the floral design. Fill in background with basket-weave stitches.

Follow blocking instructions on page 11 to return canvas to original shape.

COLOR KEY
☒ Blue 7900 (1)
⊞ Light Turquoise 7707 (1)
◯ Periwinkle Blue 7979 (1)

■ Turquoise 7516 (1)
◉ Dark Green 7346 (1)
⊞ Red 7106 (1)

▣ Magenta 7155 (1)
◻ Green 7907 (1)
⊠ Yellow 7435 (1)

◣ Medium Green 7344 (1)
☑ Dark Magenta 7685 (1)
◻ Light Magenta 7153 (1)

◻ Royal Blue 7615 (1)
☑ Dark Periwinkle 7478 (1)
Pink 7132 (19)

TEA COZY

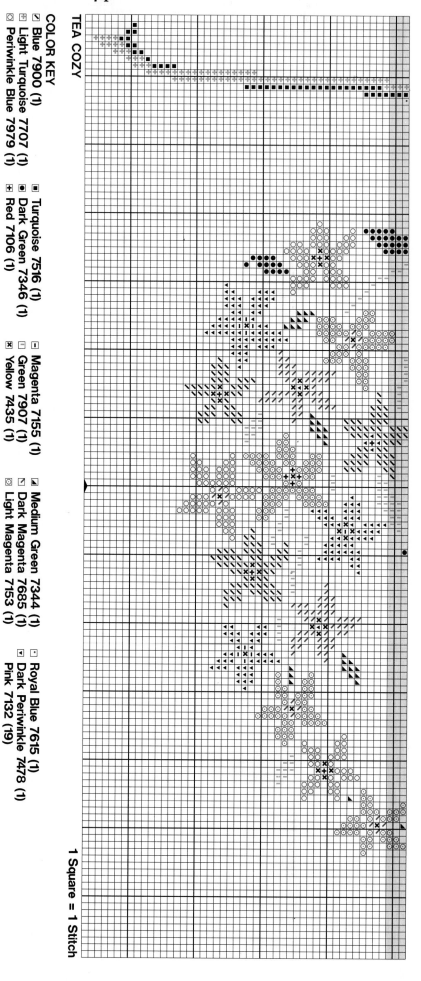

1 Square = 1 Stitch

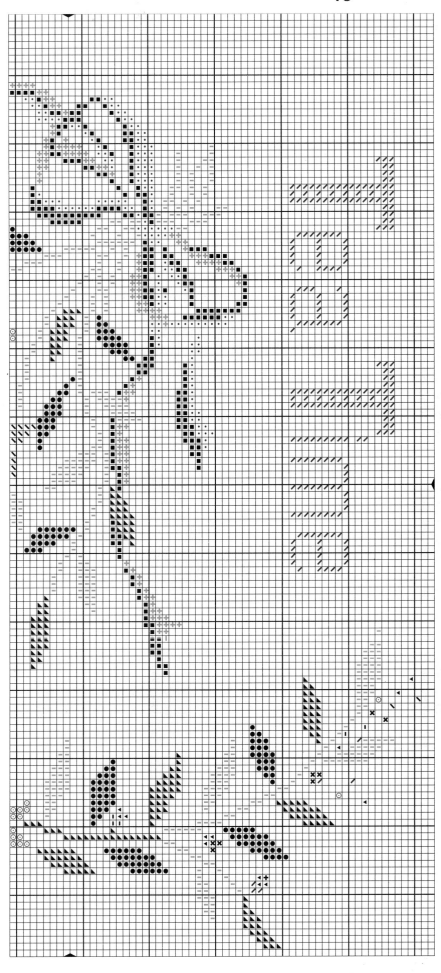

FINISHING: Trim needlepoint canvas to 2 inches beyond last row of stitches.

Mark outline on prequilted backing fabric and on a piece of fleecing for backing the needlepoint. Baste fleecing to wrong side of needlepoint.

Cover enough cord for piping to go around top, sides, bottom edge, and top loop. Machine-stitch piping and ruffle to front along outline. Add the loop of fabric-covered cord at center top. (A loop isn't necessary if you add a ruffle.)

With right sides facing, stitch front and back together along outline, leaving bottom open. Trim seams to ¼ inch past stitching; clip curves.

Turn right sides out; stitch piping along bottom edge. Turn inside out once more.

For lining, cut two cozy shapes from contrasting fabric. With right sides facing, stitch along rounded edge, leaving a 6-inch opening for turning and leaving the bottom open.

With right sides facing, stitch together raw edges along the bottom. Turn through opening in lining; slip-stitch lining closed. Smooth lining into cozy; tack in several places to secure.

Tray Insert

Shown on page 62.

Finished size of insert is 12x12 inches.

MATERIALS
16-inch square of 14-count canvas
DMC Floralia 3-strand yarn in the colors and number of skeins listed in () on the color key
White paper tape
Tapestry needle
Tray; glass to fit inside tray opening

continued

A PROFUSION OF BLOOM

INSTRUCTIONS

Bind raw edges of canvas with tape to prevent raveling.

Draw a 12-inch square on the canvas. Begin stitching 4 inches from the upper right-hand corner of the canvas as indicated by the red arrows on the pattern, *right*.

Use two strands of yarn. Work the design in continental stitch. Fill in the 12-inch-square background area with basket-weave stitches and light pink yarn. Refer to pages 24 and 25 for stitch diagrams.

If your tray is larger or smaller than the sample shown, adjust the dashed border to come within 2 inches of the tray's edge.

Follow blocking instructions on page 11 to return canvas to original shape.

Remove the tape. Fold the unworked canvas under and press flat. Insert the needlework into the tray and cover with glass to protect it.

Coaster

Shown on page 62.

Finished size of each coaster is 3¼ inches square.

MATERIALS

For one coaster

5¼-inch square of 14-count canvas
DMC Floralia 3-strand yarn in the colors listed on the color key
Backing fabric
White paper tape
Tapestry needle
Needlepoint frame (optional)

INSTRUCTIONS

Note: As each coaster is small, it may be easier to work several coasters on a larger piece of canvas mounted on a frame. Allow 2

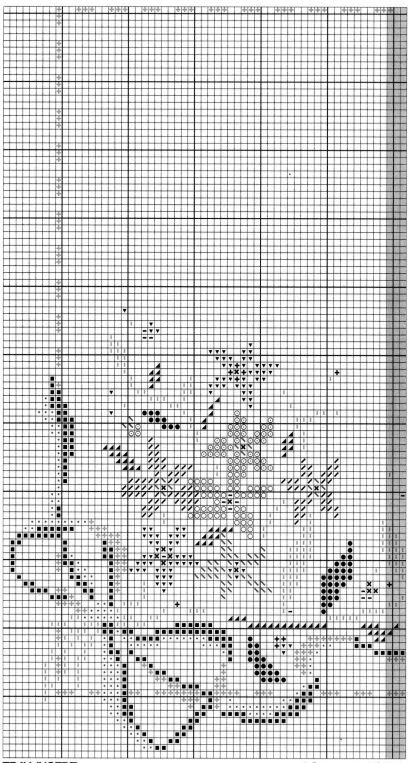

TRAY INSERT 1 Square = 1 Stitch

COLOR KEY

☑ Blue 7900	▣ Turquoise 7516	⊟ Magenta 7155
⊞ Light Turquoise 7707	◉ Dark Green 7346	⊡ Green 7907
◎ Periwinkle Blue 7979	⊞ Red 7106	☒ Yellow 7435

COASTER **1 Square = 1 Stitch**

☑ **Medium Green 7344** ☐ **Royal Blue 7615**
☒ **Dark Magenta 7685** ▾ **Dark Periwinkle 7478**
◉ **Light Magenta 7153** **Pink 7132 (24)**

inches of unworked canvas between coasters. Then cut them apart for finishing.

Note: One skein of each of the design colors will make several coasters. For the background you need approximately two skeins of yarn for each coaster.

Bind raw edges of canvas with tape to prevent raveling.

Use two strands of yarn to work this design.

Begin stitching each coaster in the upper right-hand corner as indicated by the red arrows on the chart, *above.*

Work the design in continental stitch. Fill in the background with basket-weave stitches and light pink yarn. Refer to pages 24 and 25 for stitching diagrams.

Follow blocking instructions on page 11 to return canvas to original shape.

FINISHING: Trim the coasters to within ½ inch of the last row of needlepoint stitches. Cut a backing fabric to match.

With right sides facing, stitch the front to the back along three sides. Leave the fourth side open for turning. Clip corners; turn right sides out. Slip-stitch opening closed.

Steam press back to flatten.

TIPS AND TECHNIQUES

Needlepoint is an old-time craft that is simple to master once you've learned the basics.

To guide you through the needlepoint projects in this book, here are tips for working the stitches and for selecting canvas, yarns, needles, and needlepoint frames.

Needlepoint Canvas

Needlepoint canvas is a sturdy, open-weave fabric that is used as a framework for the stitches that are worked onto it. It is available in several weaves and a large number of widths. It is sized according to the number of vertical threads per inch. For example, No. 10 canvas has 10 vertical threads to each inch; No. 14 has 14 vertical threads to the inch.

Mono canvas is made with single threads running vertically and horizontally and woven together in a plain over-and-under weave so each mesh, or space between threads, is the same size.

Double mesh canvas, also called Penelope canvas, is made with *double* threads running vertically and horizontally. It's a strong canvas that can be used for regular stitches that cover the double threads (gros point) or for fine stitches worked into the smaller spaces formed by the double threads (petit point).

Interlock canvas is made with single threads running horizontally and doubled threads running vertically. The doubled threads lock around the single threads creating a locked-weave canvas. This canvas is more resistant to raveling and distortion from the pull of the stitches.

Most needlepoint canvas is white, but some ecru, tan, and peach shades also are available. Cotton and linen canvases are easily dyed if you want a particular color or are planning to leave the background of your design unstitched.

Yarns and Threads

There are no limits when it comes to choosing yarns and threads for needlepoint, as long as you can thread the fiber you've selected through the eye of a blunt-end needle. Don't hesitate to use wool, cotton, linen, and silk yarns, as well as metallic threads, ribbons, embroidery floss, perle cotton, and even fabric strips for special effects. Refer to the chart, *opposite,* for a quick guide to the appropriate needle size and number of yarn strands for the different canvas gauges. This chart is based on continental and basketweave stitches. For other stitches, you may have to add a strand or two of yarn.

Wool is the most popular yarn for traditional needlepoint. Of the many types available, Persian wool is the most widely used because it wears well, is easy to work with, and is available in more than 300 colors. It can be purchased in 1-yard lengths or by the skein. Persian wool is made of three strands loosely plied together so they can be separated and used individually. As a guide, use three strands of yarn on 10-count canvas, two strands on 12- and 14-count canvas, and one strand on 16- and 18-count canvas.

Tapestry wool is a single-strand yarn that can be used in place of three strands of Persian wool. It is nondivisible so its use is limited to 10- and 12-count canvas.

Crewel yarn, used for embroidery, is a finer, single-strand yarn. A single strand can be combined with additional strands to make a thicker yarn to stitch on any size canvas. Used singly, it is especially nice for working petit point stitches.

When purchasing yarn, try to buy enough for the entire project so you can be sure colors match. Also, look for colorfast yarns so you don't ruin a beautiful piece of handwork in the blocking stage.

Needles and Other Tools

For stitching needlepoint, use tapestry needles with blunt tips and large, elongated eyes. Blunt tips help you avoid splitting the yarns or threads of the canvas, and an elongated eye won't put undue stress on the yarn in the needle. The eye of the needle should be large enough to hold the thread easily, but narrow enough to pass through the mesh on the canvas without distorting the threads.

Refer to the chart, *opposite,* for the correct needle sizes to use on the different counts of canvas.

Equipment needed in addition to needles includes scissors with sharp, narrow points for snipping out mistakes, and 1-inch-wide white paper tape or bias fold tape. Use the paper or bias tape to cover the canvas edges. This prevents the canvas from raveling and protects the yarn while stitching. We suggest that you avoid using masking tape on the edges because it might leave a glue residue on the canvas.

Frames

Many needlepointers mount their canvases in a frame for working, freeing both hands for stitching (with one hand atop the canvas and the other beneath it). This method results in a more even tension and minimizes distortion of the canvas during stitching. Also, large needlepoint projects are more manageable when using a frame.

There are several types of frames available. A scroll or slate frame is the most commonly used because it's adjustable and is available in several sizes. To use one, attach the canvas to the rollers at the top and bottom and lace it to the sides, making sure the grain of the canvas is straight as you attach it to the frame. The rollers turn the canvas so you can work the design in small areas.

Floor stands with a mounted frame also are useful because

FOR NEEDLEPOINT

they allow you to use both your hands for stitching.

To make your own frame, assemble artist's stretcher strips into a frame at least 1 inch larger on all sides than your project. Staple or tack your canvas to the frame with grain lines straight.

If you wish to work in your lap without a frame, roll the canvas around a cardboard tube and secure the rolled canvas to the cardboard with paper clips.

Stitching techniques

Cut yarn or thread into workable lengths so it won't look worn from being pulled through the canvas too often. For best results, cut floss or perle cotton into 36-inch lengths and wool strands into 18-inch lengths. Silk and metallic threads should be cut into 12- or 14-inch lengths.

To create smoother looking stitches and to give the yarn or floss more loft, separate the strands of Persian wool and embroidery floss. Then thread the needle with the required number of strands to fill the canvas. This minimizes the amount of twist in the yarn and makes the stitches lie flatter and smoother.

While the number of strands used for a stitch depends on the size of the canvas, it also is influenced by the direction of the stitches. Diagonal stitches, such as continental, lie directly over an intersection of threads. Straight stitches, such as bargello, lie between the threads and may require additional strands to cover the canvas adequately. Plan to use one or more additional strands in the needle for straight stitches than for diagonal ones if necessary.

Knots tied on the back of the canvas can cause unsightly bumps in the design. To avoid this, weave the ends of the yarn into the back of the work, or begin and end with waste knots. To make a waste knot, knot the end of the yarn and insert the needle

Needle and Yarn Guide

Canvas Gauge	Needle Size	Persian Strands	Floss Strands	Perle Cotton
10-mesh	#16	3	10-14	—
12-mesh	#18	3	8-11	Size 3
14-mesh	#20 or 22	2	6-9	Size 3
16-mesh	#22	2	4-7	Size 5
18-mesh	#22 or 24	1	3-5	Size 5

into the canvas from front to back 10 stitches from the point where you will begin to stitch with the new thread (the knot is on top of the work). Then stitch over the thread end on the back side, securing it. Clip the knot and pull the end of the yarn to the back side of the canvas.

If you are a beginning needlepointer—or an experienced one learning a new stitch—keep scrap canvas handy for practice stitiches. The time spent mastering a new stitch will be amply rewarded when you switch to your actual project canvas. The tension on the stitches will be more uniform once you've mastered the technique, and you'll spend less time picking out inaccurate or unattractive stitches.

To avoid splitting and damaging stitches already worked, stitch from an empty mesh to a full mesh whenever possible.

As you stitch, maintain even tension on the thread from stitch to stitch. If you pull the yarn too tight, it will not cover the canvas completely. When worked too loosely, yarn tends to snag easily. With uniform tension, the stitches will look better and you'll be less apt to distort the canvas.

Finally, it's easiest to stitch a design with separate needles threaded with yarn in each color. When working with several nee-

dles, however, it is best not to carry the yarn more than a few meshes across the back of the canvas. Instead, weave the thread underneath the stitches already worked. Or, weave the thread into the back of a stitch, clip the thread, and start fresh in the new location on the canvas.

When stitching background areas that need to be adjusted to fit a particular item (a chair seat or piano bench, for example), you can determine the amount of thread or yarn you need to purchase using the following method. First, figure in inches the length and the width of the finished stitched canvas; multiply these two figures. Then measure the approximate length and width of the design image; multiply these two figures. Subtract the image measurement from the finished stitched canvas measurement to determine the number of background inches.

Beginning with one 36-inch length of the yarn or thread you are using for the project, stitch one square inch of the canvas, keeping track of the number of yards to complete the square inch. Multiply the number of yards per square inch times the number of background inches to determine the amount of yarn or thread needed to complete the project.

ACKNOWLEDGMENTS

We would like to extend our special thanks to the following designers who contributed projects to this book. When more than one project appears on a page, the acknowledgment cites both the project and the page number. A page number alone indicates one designer contributed all of the projects on that page.

Cheryl Drivdahl—61

Dixie Falls—30–31, 52–53, 60, 62–63

Rebecca Jerdee—32–33

Marsha Lee—20–21

Beverly Rivers—58–59

Jim Williams—8–9, 26–29, 56–57

We would like to thank the following person whose technical skills are greatly appreciated.

Margaret Sindelar

We also are pleased to acknowledge the following photographers whose talents and technical skills contributed much to this book.

Dennis Becker—58, 60 (inset)

Susan Gilmore—32–33

Hopkins Associates—4–9, 20–21, 26–31, 52–53, 56–57, 59–63

For their cooperation and courtesy, we extend a special thanks to the following sources for providing materials for projects and props for photography.

Alice Peterson Company
1591 E. El Segundo Blvd.
El Segundo, CA 90245-4305
 for eyeglass case on page 31

Anne Brinkley Designs
21 Ransom Road
Newton Centre, MA 02159
 for crystal jar on page 60
 (inset)

The DMC Corporation
P.O. Box 500
Port Kearney, Building 10
South Kearney, NJ 07032-0500
 for floss and Persian yarn

Dot's Frame Shop
4521 Fleur Drive
Des Moines, IA 50321

Dritz Corporation
P.O. Box 5028
Spartanburg, SC 29304
 for buttons on page 60

Fitz & Floyd
225 5th Avenue
New York, NY 10010
 for props on pages 27–29

G.W.M. Industries, Inc.
161 Avenue of the Americas
New York, NY 10013
 for perforated paper

Plain n' Fancy
Box 357
Mathews, VA 23109
 for boxes on pages 20 and 59

Raintree Designs
New York Sales Office
979 Third Ave, Suite 503 N.
New York, NY 10022
 for fabrics on pages 56–57

Sudberry House
Box 895
Old Lyme, CT 06371
 for tray on page 62